4/00

Sue & Bill —
This book will bring
you back again and again!
The Roys

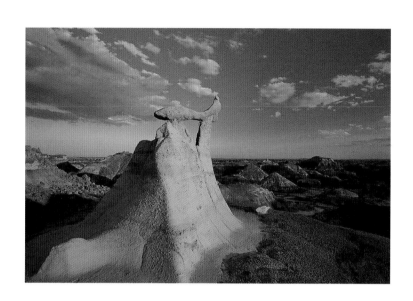

NEW MEXICO

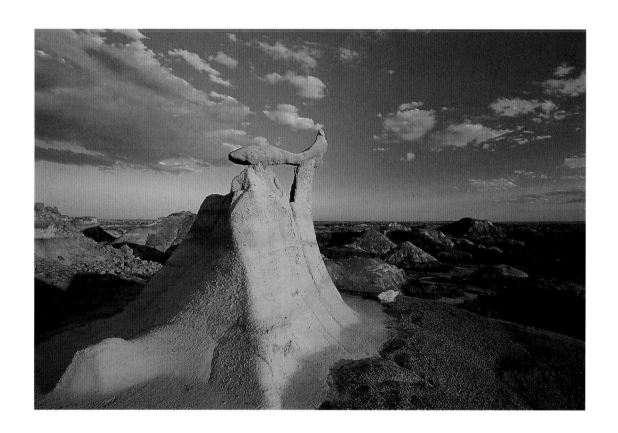

WHITECAP BOOKS

VANCOUVER / TORONTO / NEW YORK

Text by Tanya Lloyd
Edited by Elaine Jones
Proofread by Lisa Collins
Photoediting by Antonia Banyard
Typesetting by Jennifer Conroy
Cover and interior design by Steve Penner

Printed and bound in Canada

Canadian Cataloguing in Publication Data

Lloyd, Tanya, 1973–

 New Mexico

 ISBN 1-55110-863-1

 1. New Mexico—Pictorial works. I. Title.
F797.L66 1999 978.9$'$053$'$0222 C98-911019-2

The publisher acknowledges the support of the Canada Council and the
Cultural Services Branch of the Government of British Columbia in making this
publication possible. We acknowledge the financial support of the Government
of Canada through the Book Publishing Industry Development Program for our
publishing activities.

For more information on the America Series and other Whitecap Books
titles, please visit our web site at www.whitecap.ca.

To travel through New Mexico is to wander into an ancient landscape, carved by churning rivers, spewing volcanoes, and dry desert winds. More than two million years ago, much of this land was seabed and lush swampland, home to enormous dinosaurs and thousands of tiny plant forms. The spectacular caves and chasms of Carlsbad Caverns were once an ocean reef. Here, and in many sites throughout New Mexico, visitors can stroll a few steps from their cars into a prehistoric setting.

Just as easily, sightseers can find themselves immersed in the culture of the Anasazi—"the ancient ones." More than a thousand years ago, these people began building sophisticated cities throughout the state, complete with intricate road and water systems. Scientists exploring the sites of Chaco Canyon believe it was once the largest settlement in North America. And yet, in the 12th century, all signs of the Anasazi abruptly disappeared.

It is obvious why New Mexico is called "the Land of Enchantment." Its rich history combines with an array of sacred sites to contribute to the reputation. At Aztec Ruins National Monument, archeologists have reconstructed the Great Kiva, once a huge ceremonial chamber. On the Navajo Reservation, the famous geological formation known as Shiprock is renowned for its role in legend, when it is said to have flown a Navajo group to safety during an enemy attack. And the state's sacred sites are not all from ancient times. In the early 1800s, Don Bernardo Abeyta founded a church at the place he was healed, and believers from across the continent continue to travel to El Santuario de Chimayó in search of its powers.

Perhaps it is New Mexico's reputation for mystery that has attracted the state's growing population of artists and artisans. From the traditional pottery of the pueblos and colorful Spanish dances to modern architecture and painting, art and culture permeate the streets of Albuquerque, Santa Fe, and the surrounding small communities. Whether it is the land's enchantment, the crystal clear light of the Southwest, or the state's distinctive cultures, the landscape of New Mexico has inspired awe in millions of residents and visitors.

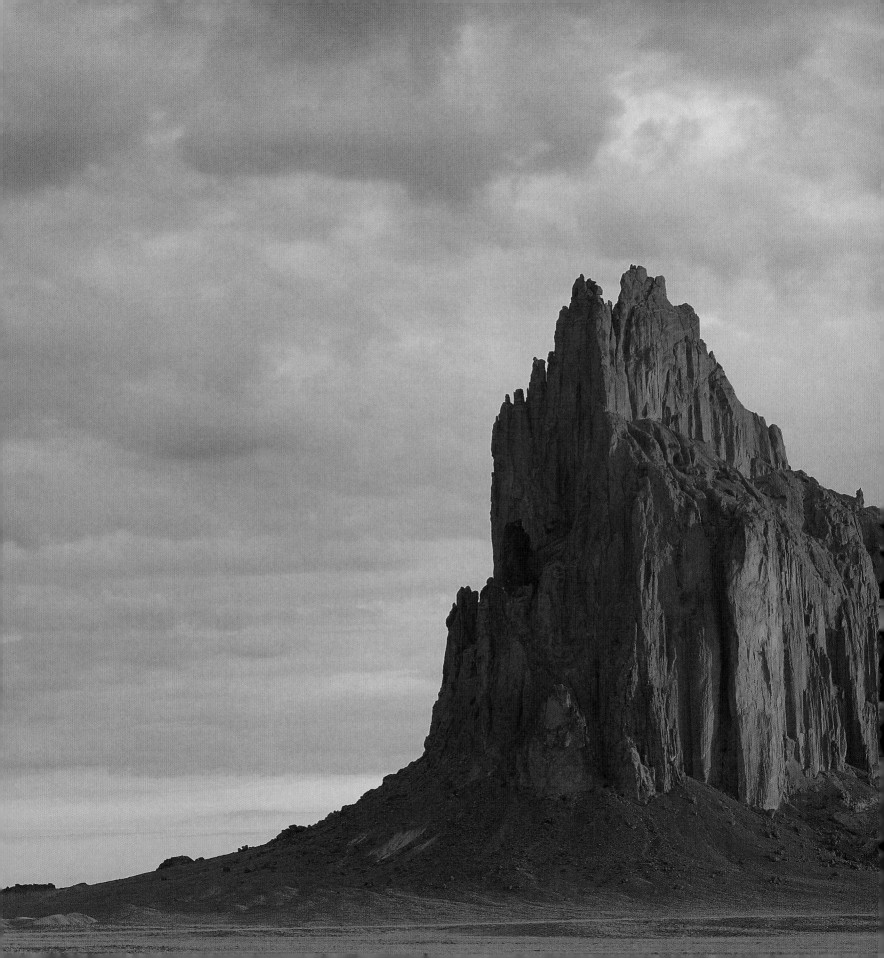

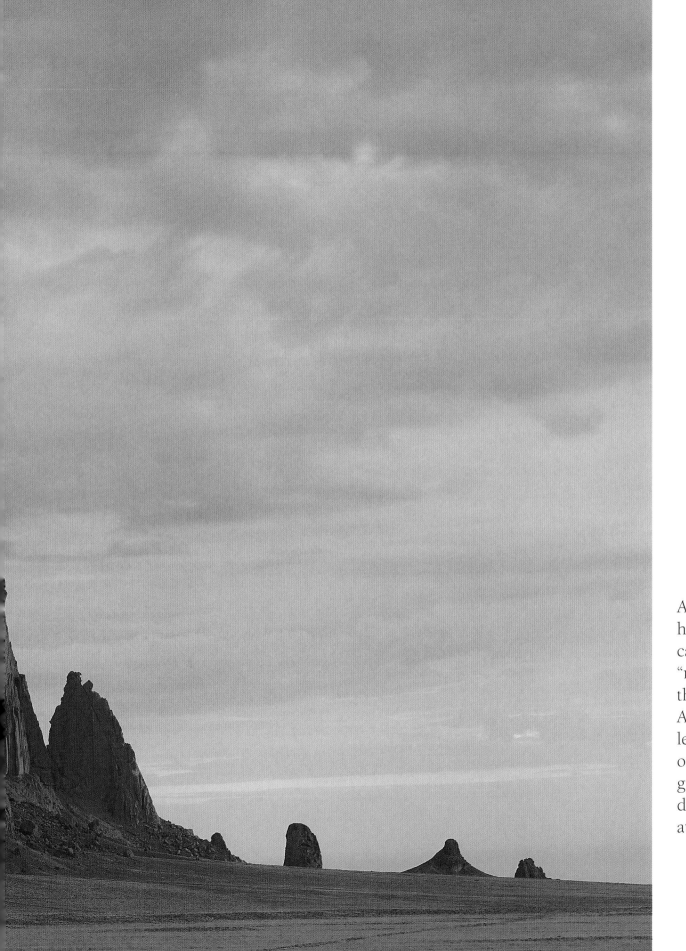

About 1,700 feet high, Shiprock is called Tse Bida'hi, or "rock with wings," by the Navajo people. According to one legend, this rock once flew a Navajo group to safety during an enemy attack.

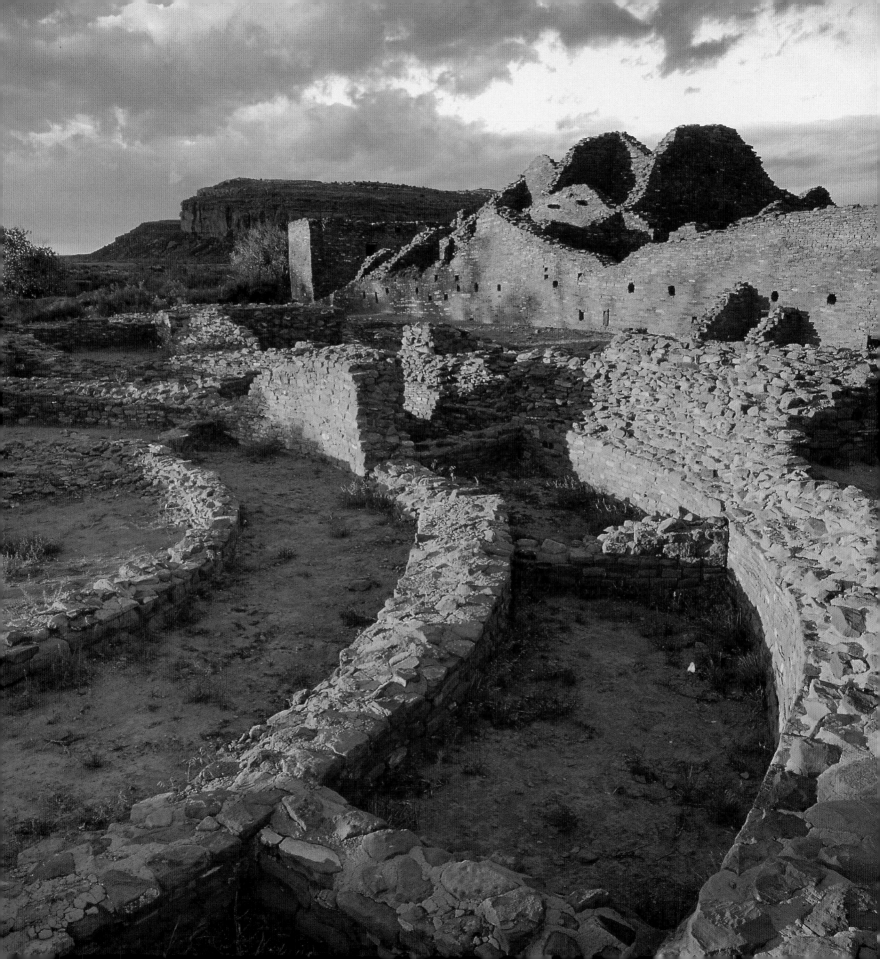

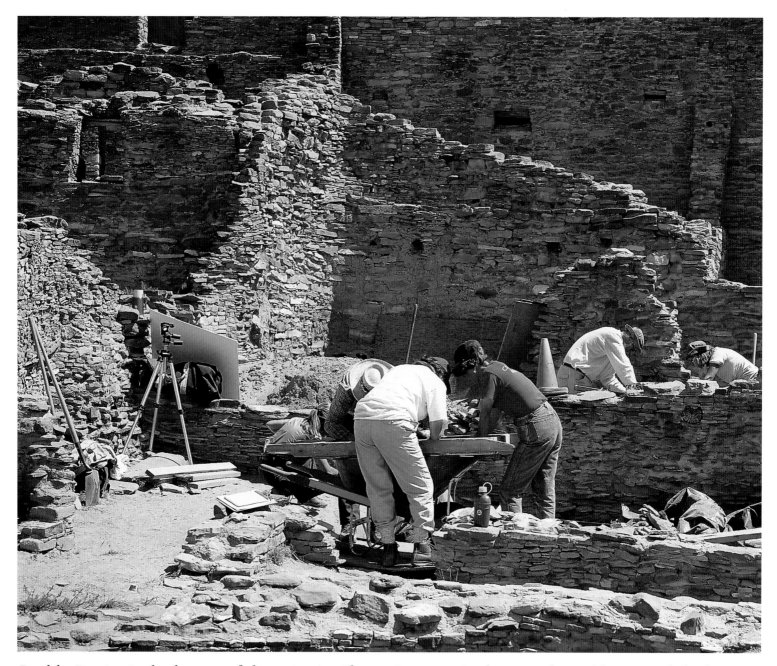

Pueblo Bonito is the largest of the ruins in Chaco Canyon. Civilization thrived here until the late 12th century, when all signs of the Anasazi abruptly disappeared. Scientists have yet to discover why the pueblos were abandoned, although it may have been related to drought, or to the arrival of the Apache and Navajo people.

Protected by Chaco Culture National Historic Park, Pueblo del Arroyo boasts 280 rooms and is one of 13 major pueblos discovered in Chaco Canyon. This is the largest of the Anasazi settlements found throughout the state.

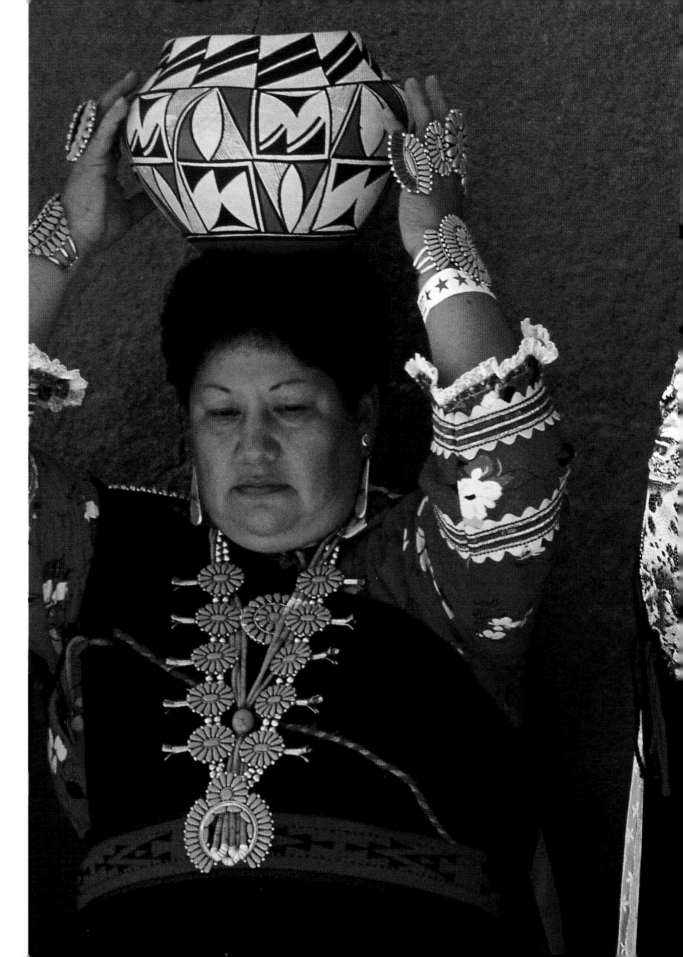

Zuni women dance at Gallup's Intertribal Indian Ceremonial at Red Rock State Park. These dances have been performed for hundreds of years, even after they were banned by the Spanish.

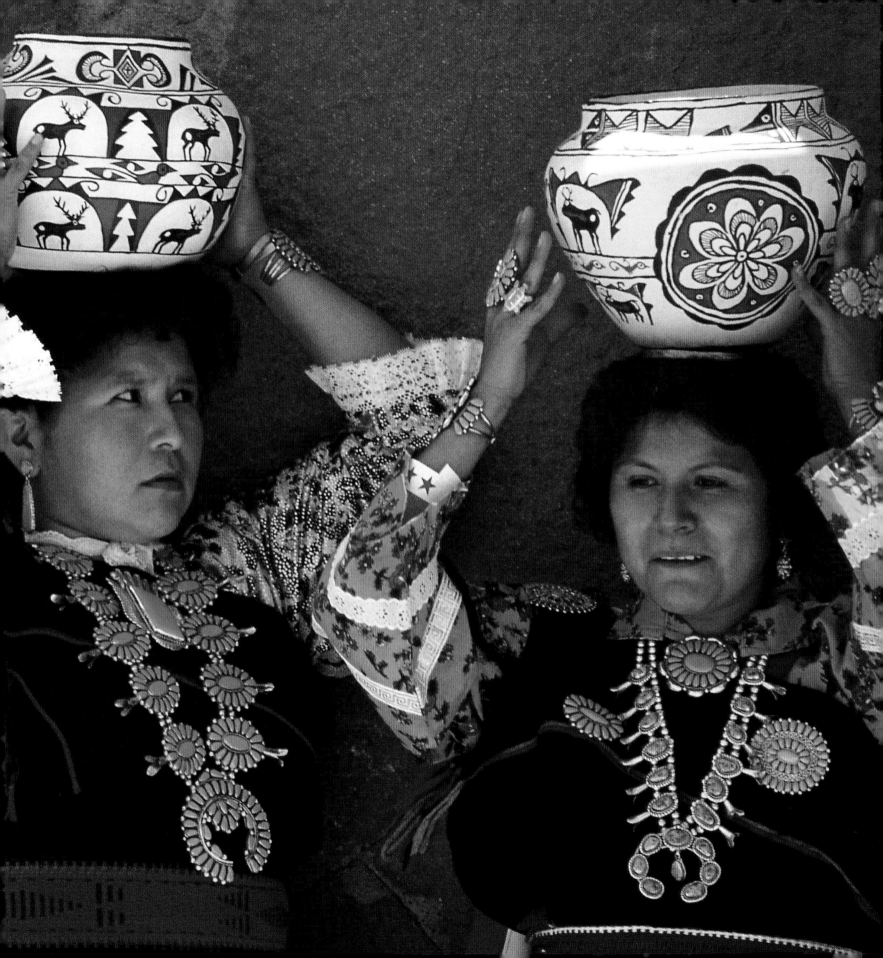

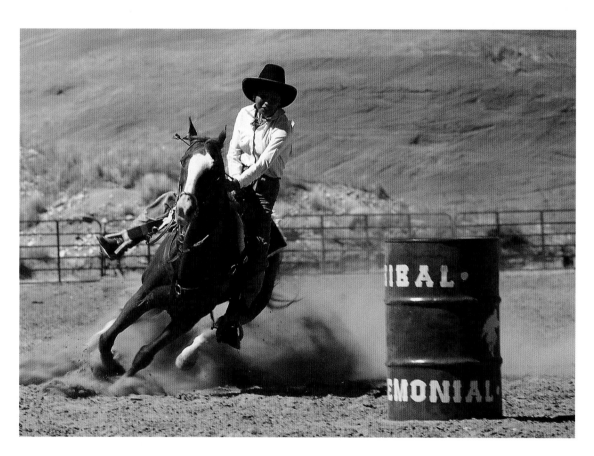

The 6,800-seat arena at Red Rock State Park is the perfect venue for barrel racing, just one of many summer festivities in the Gallup area.

From Glen Rio to Gallup, historic Route 66 is lined with a few motels and eateries, which recall the glory days of America's "Mother Road."

Ancient pictographs exist side-by-side with the names of 17th- and 18th-century travelers on Inscription Rock in El Morro National Monument. The 200-foot-high rock sits below the ruins of Zuni pueblos.

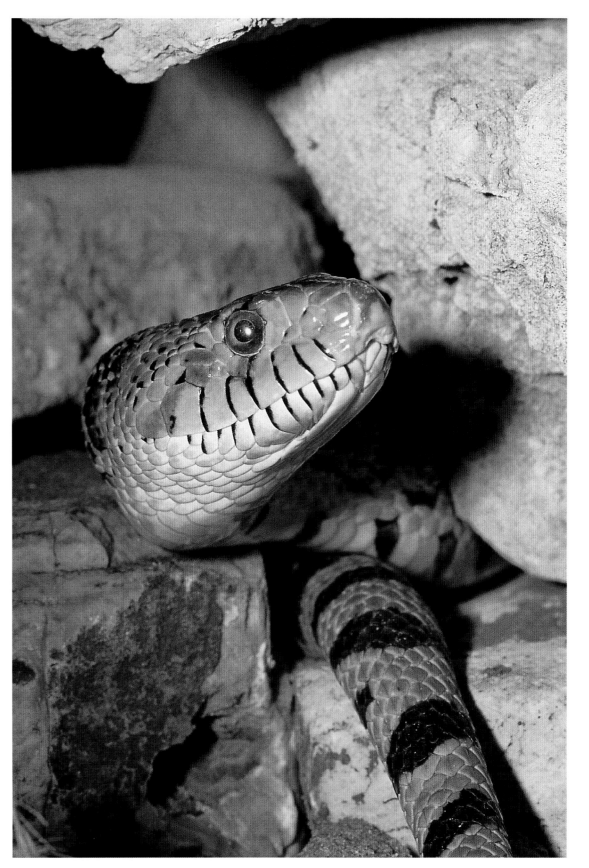

The gopher snake is sometimes mistaken for a rattlesnake because of its similar coiled defensive posture and vibrating tail. There are several snake species found in the Southwest, and hikers follow the rule, "Never put your foot where you can't see it."

Built in 1699, the San Jose de Laguna Mission Church has been influenced both by the Spanish, who prompted its construction, and by Laguna's diverse native craftspeople, who created the artistically designed interior.

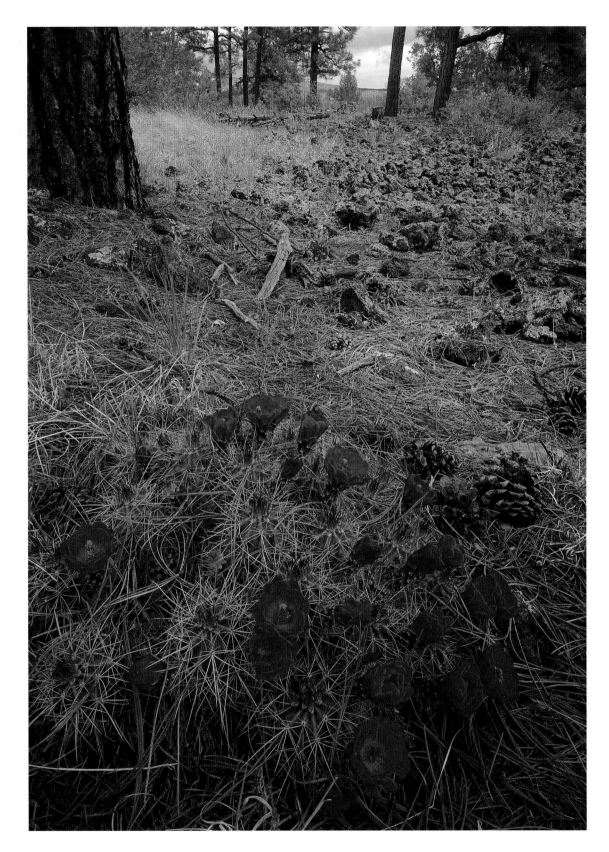

Named for the wine-goblet shape of its large, scarlet flowers, claret cup cactus blooms throughout the Southwest in late spring.

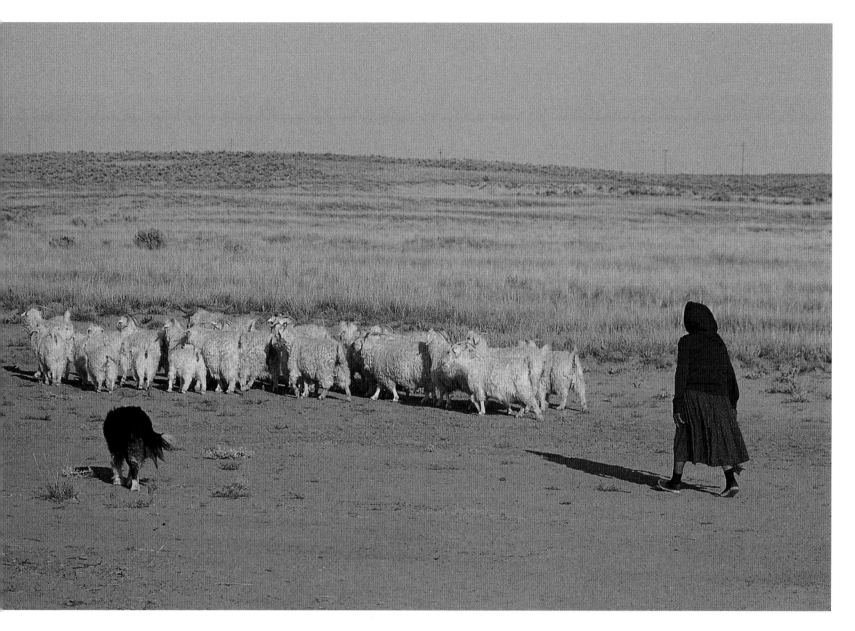

The Navajo people are believed to have arrived in New Mexico in the 13th or 14th century. Traditionally, they were semi-nomadic people, farming in some seasons and traveling in others.

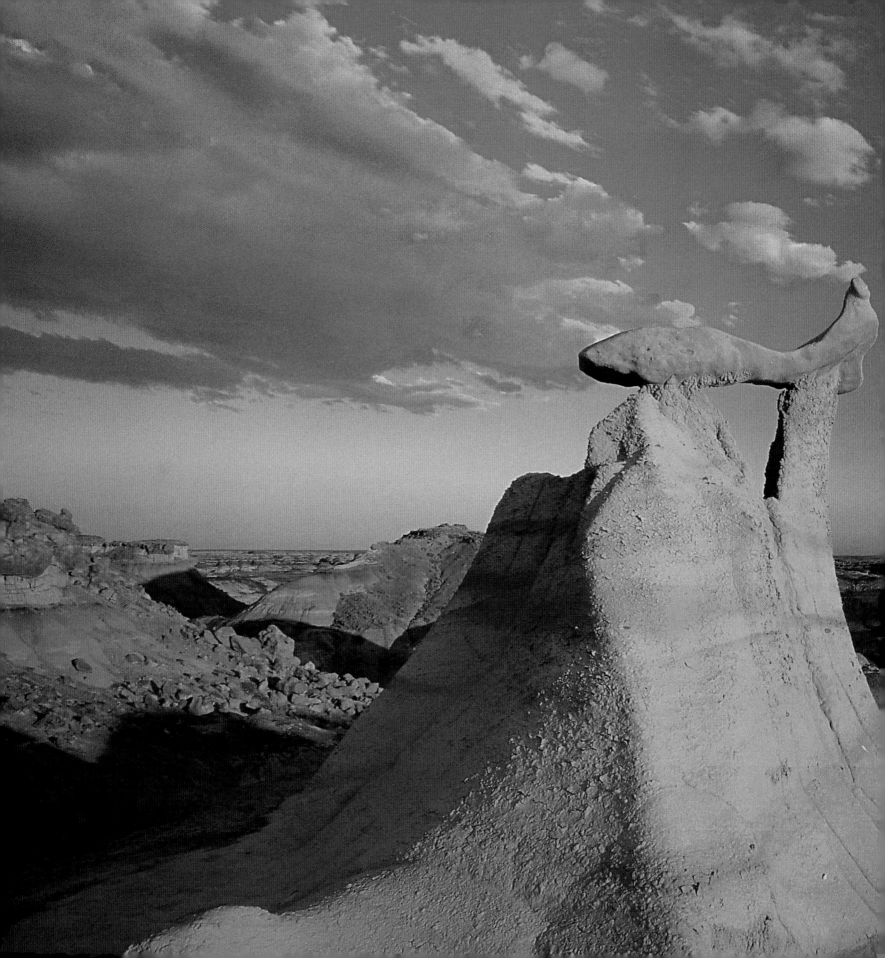

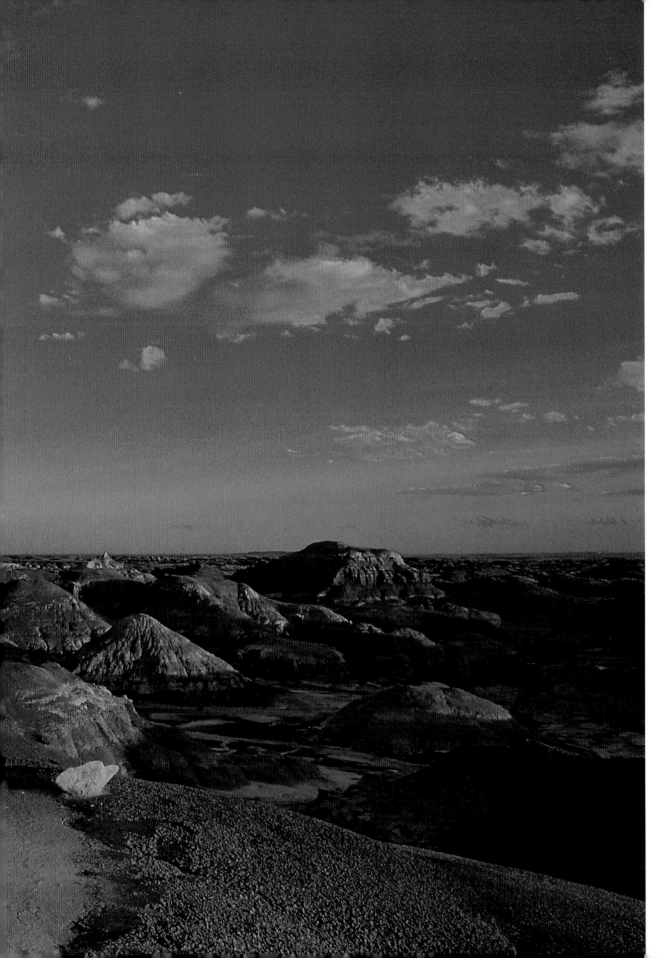

Erosion has swept
away the softer soil
of the Bisti Badlands,
leaving strangely
shaped hoodoos
behind. Once a
prehistoric swamp,
this area is rich in coal.

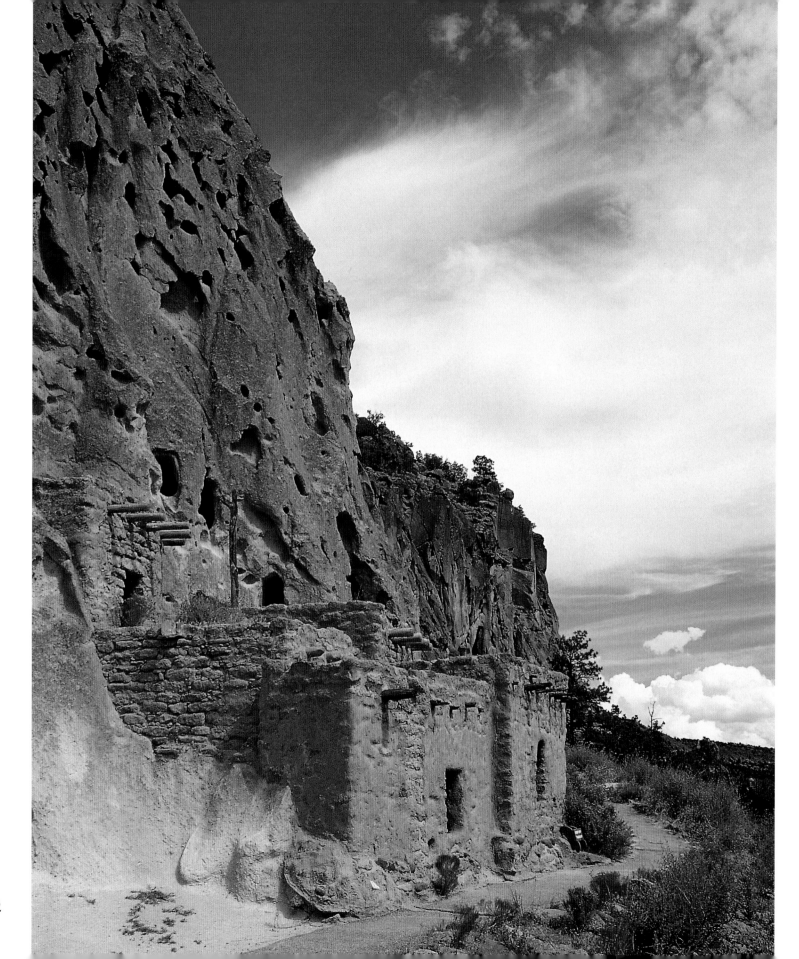

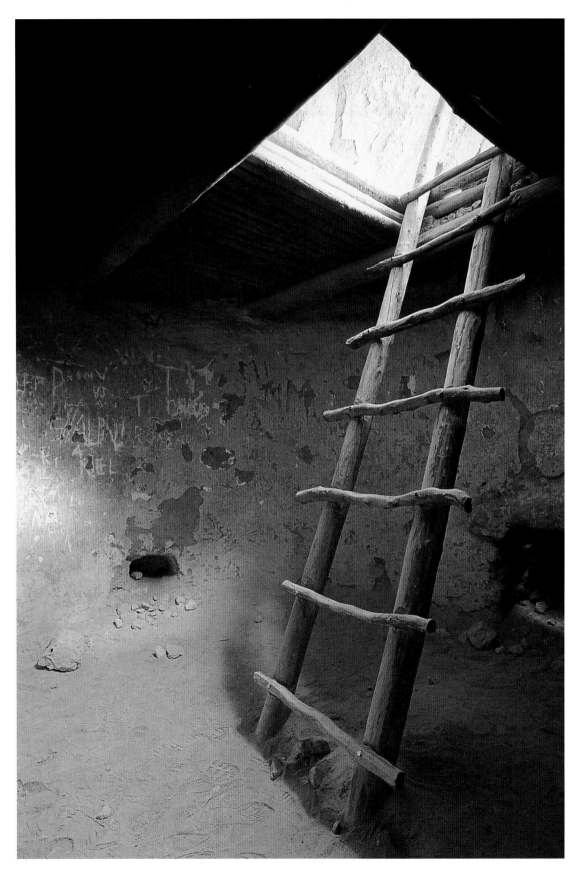

Bandelier National Monument is named for Adolf Bandelier, who explored these ruins in the 1880s, along with several other forgotten settlements of the Southwest.

OPPOSITE— Established in 1916, the Bandelier National Monument protects archeological sites within a 36,000-acre area. The Anasazi people lived here about 2,000 years ago and their cliff dwellings— apartment-style complexes built into cliff faces— continue to fascinate archeologists.

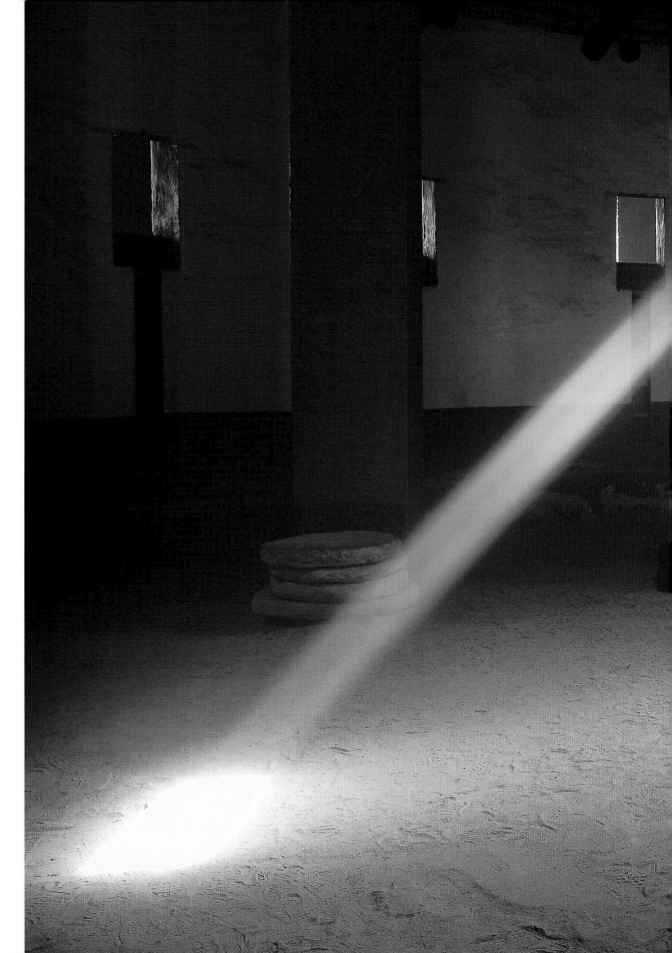

The Great Kiva is the largest building to be reconstructed at the Aztec Ruins National Monument. Named for the town of Aztec, the monument actually protects 12th-century Anasazi ruins.

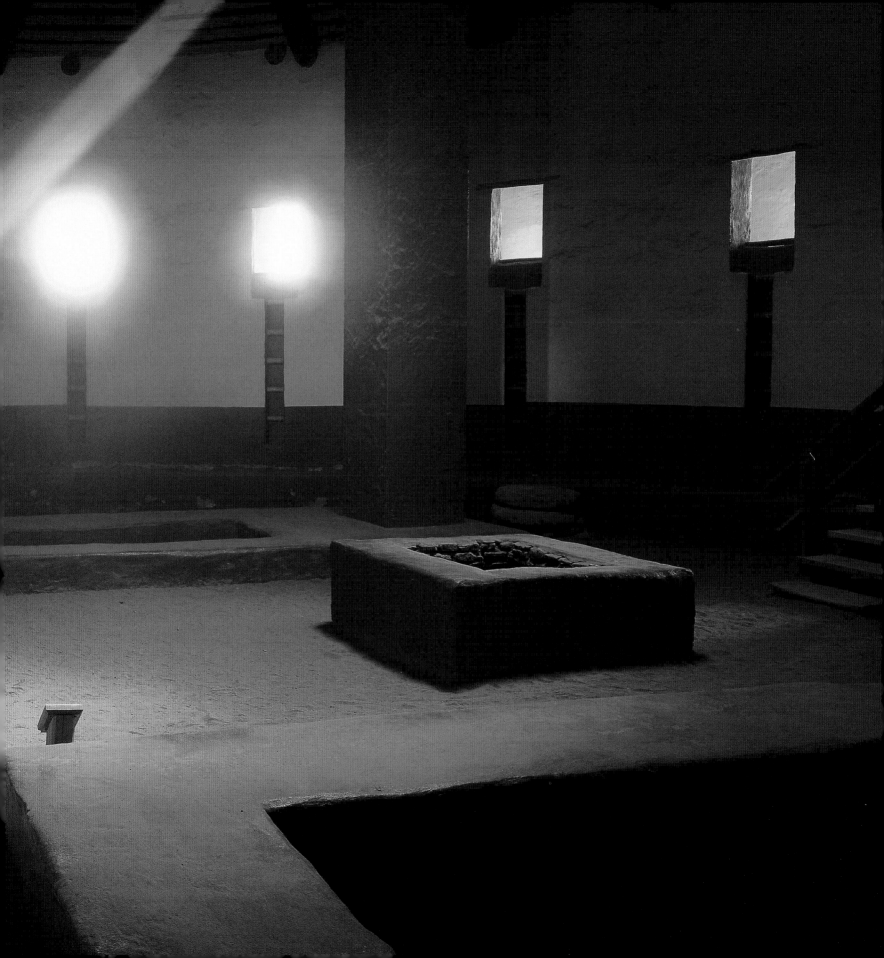

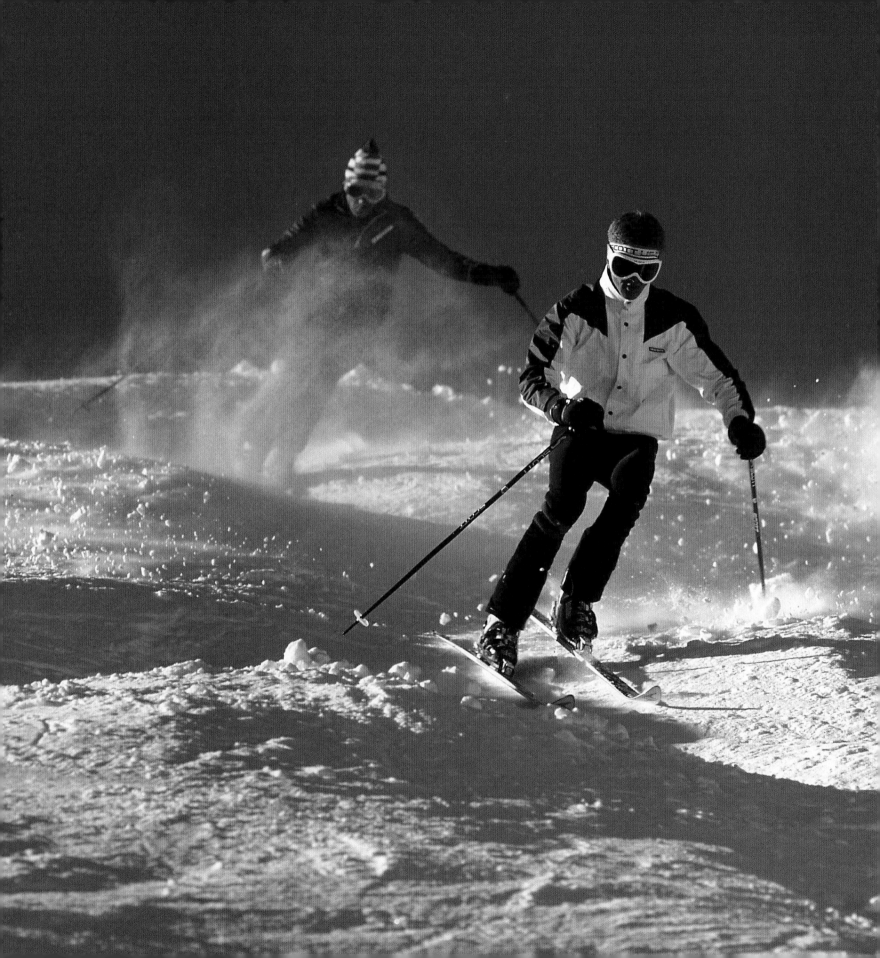

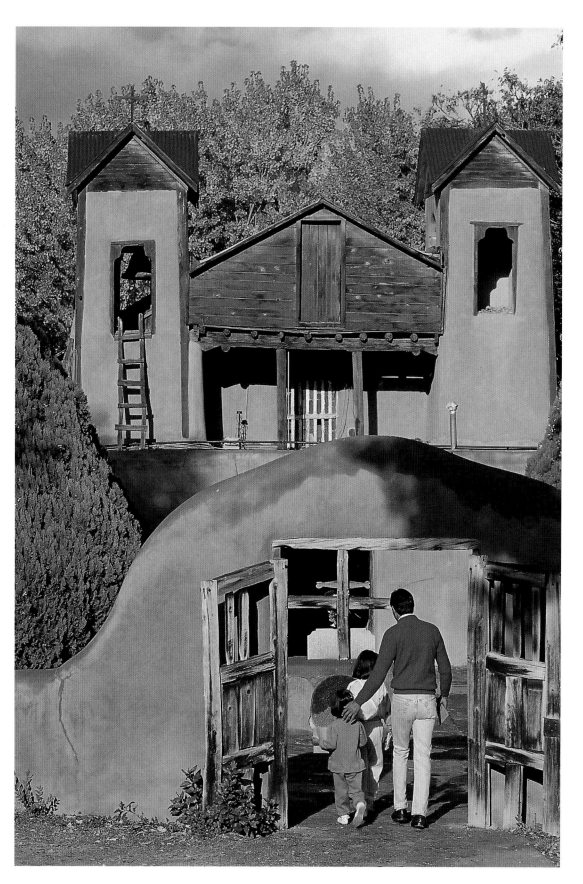

When Don Bernardo Abeyta was healed by the earth at this site in the 1800s, he founded El Santuario de Chimayó. Since then, the church has been surrounded by tales of miracles and healings.

OPPOSITE—
Skiing meccas such as Taos and Santa Fe attract skiers and snowboarders from across the continent.

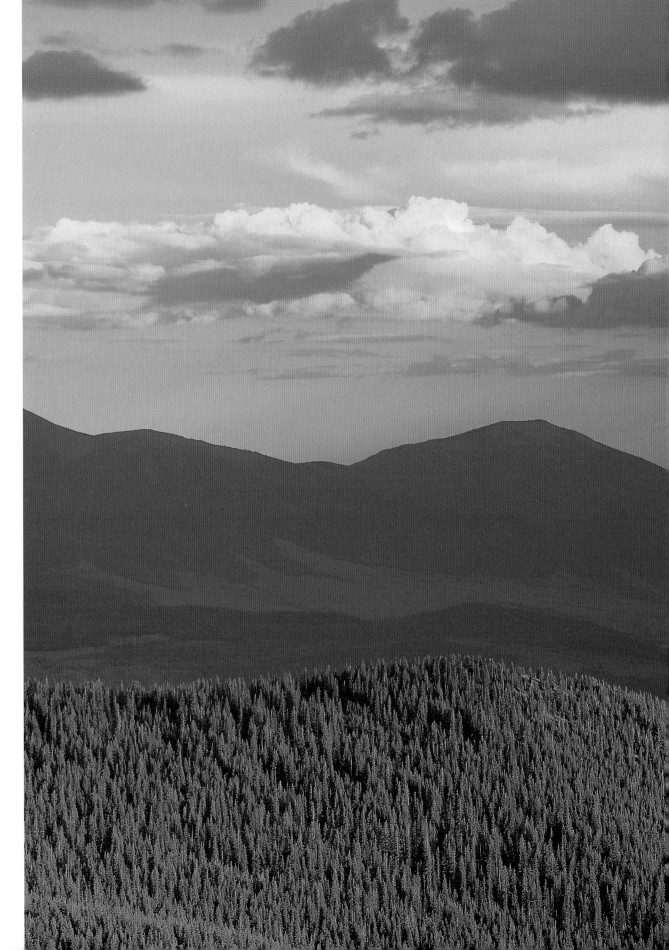

A popular hiking and camping destination, the mountains of Carson National Forest, including 13,161-foot Wheeler Peak, draw visitors from across the state.

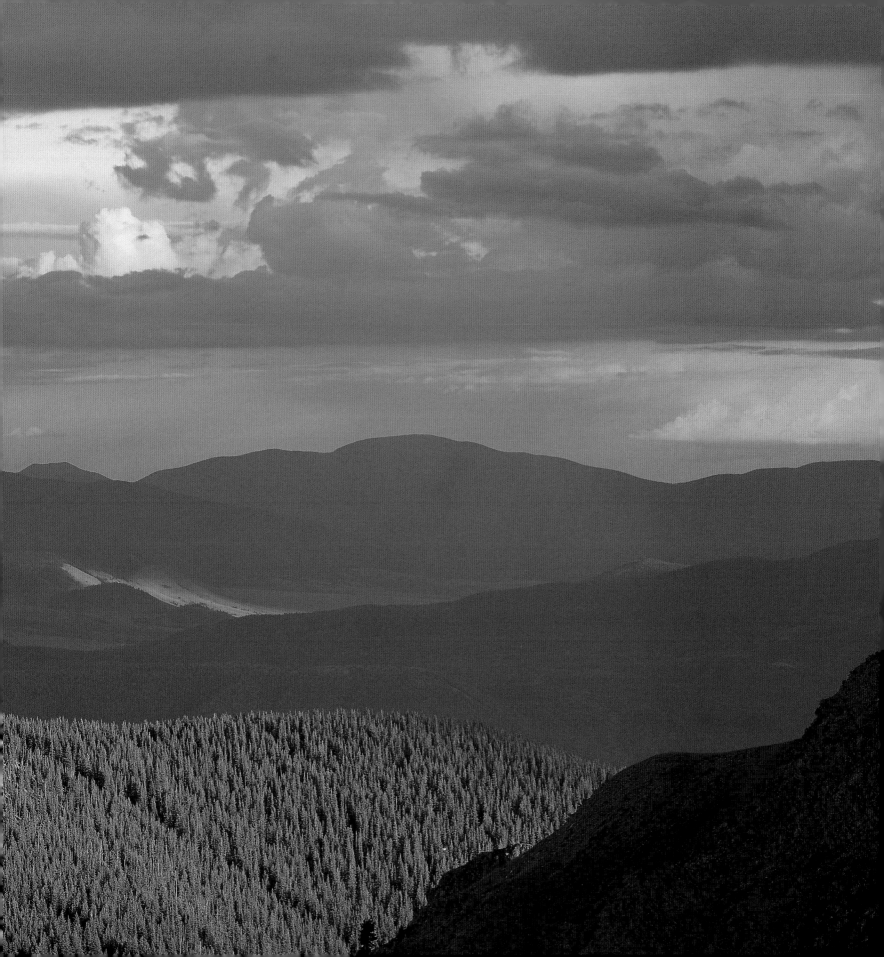

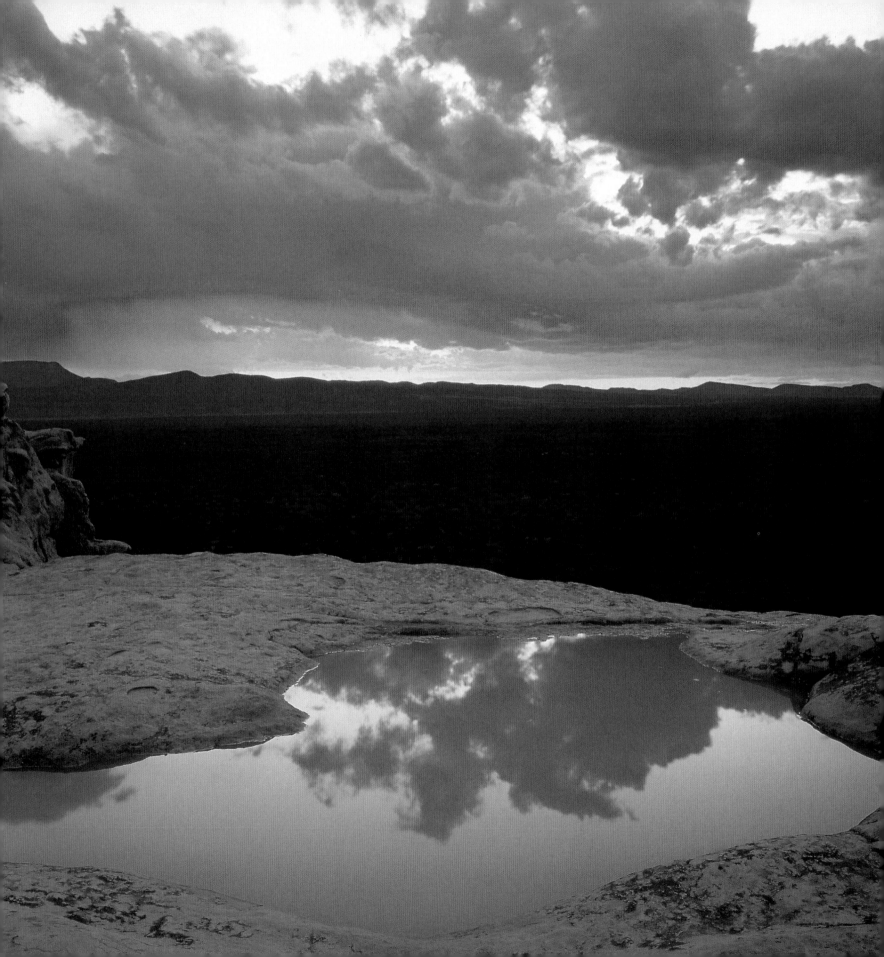

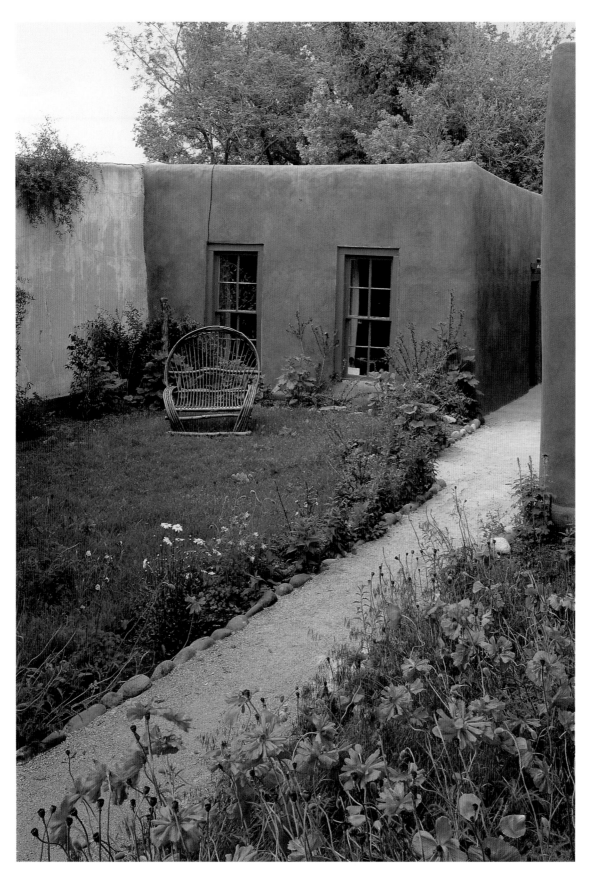

The town of Taos was built by the Spanish in the mid-1600s, when the relationship between the native people of Taos Pueblo and the Spanish became strained and the Spanish were asked to move farther away.

OPPOSITE—
El Malpais National Monument—named for "badlands" in Spanish—protects 376,000 acres. Lava spires, arches, and sandstone water-pockets make this one of New Mexico's most unique landscapes.

Historic and cultural sites draw 143,000 international visitors each year. Most come from Germany, France, and the United Kingdom.

OPPOSITE—
This outdoor oven—called a horno—is one of many still used by the native people of Taos Pueblo. As tourism draws more people, pueblo residents often cook before the curious eyes of visitors.

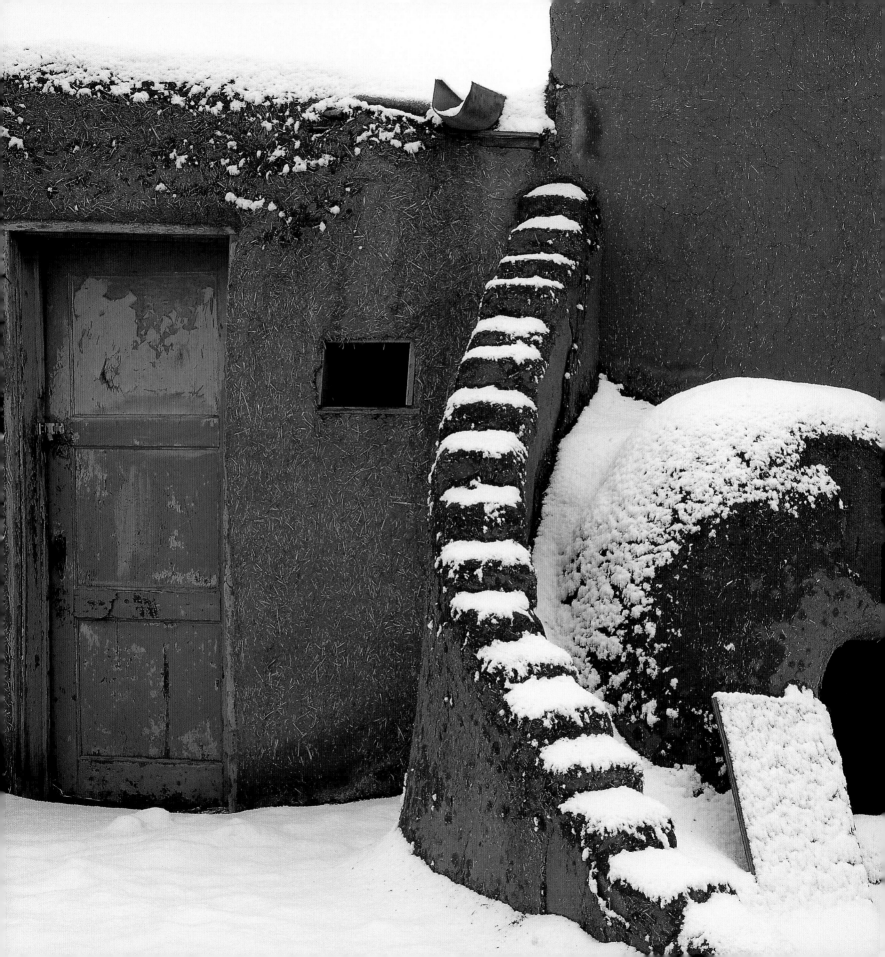

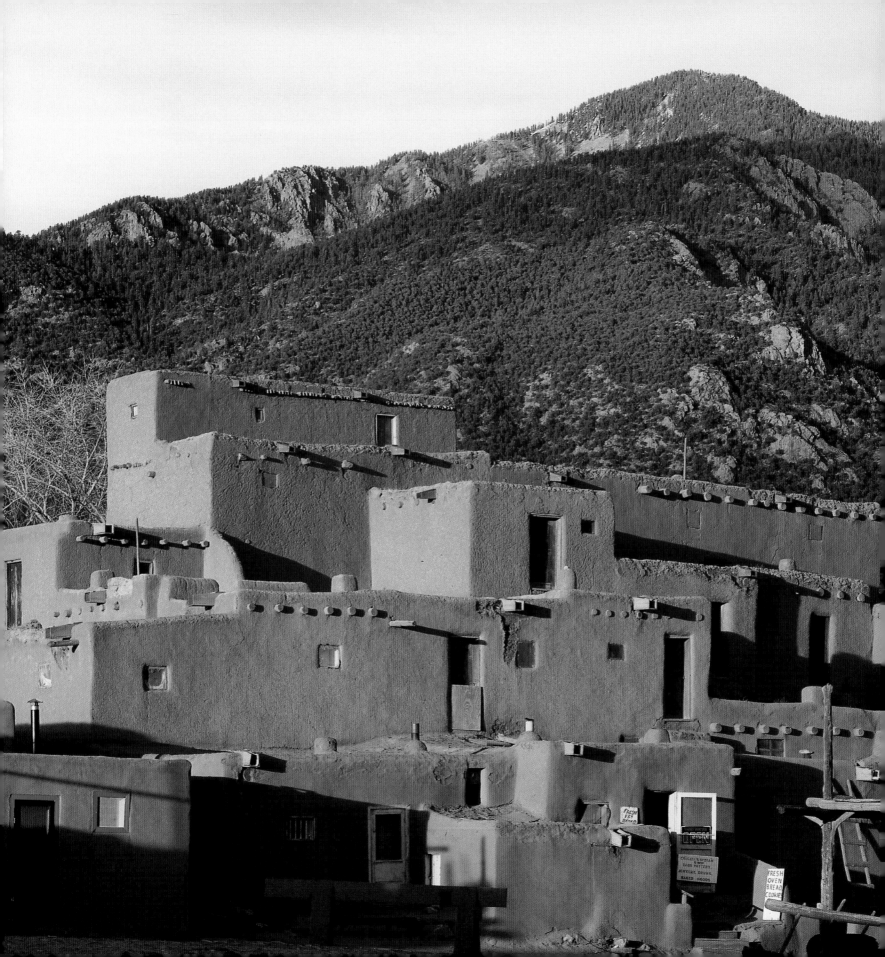

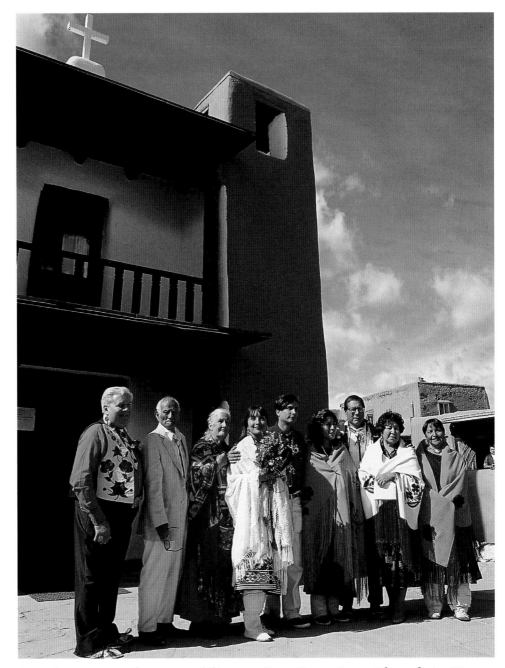

Revelers pose after a wedding at San Geronimo Church in Taos Pueblo. Some of the pueblo's scenes have been immortalized in the paintings of local artist Georgia O'Keefe.

The Taos Pueblo has been continually inhabited for about 800 years. Residents today live without running water or electricity, preserving a traditional way of life.

Elizabeth Case Harwood and a group of local artists created the Harwood Foundation in 1923 to serve as a museum, library, and education center. The foundation became part of the University of New Mexico in 1936.

36

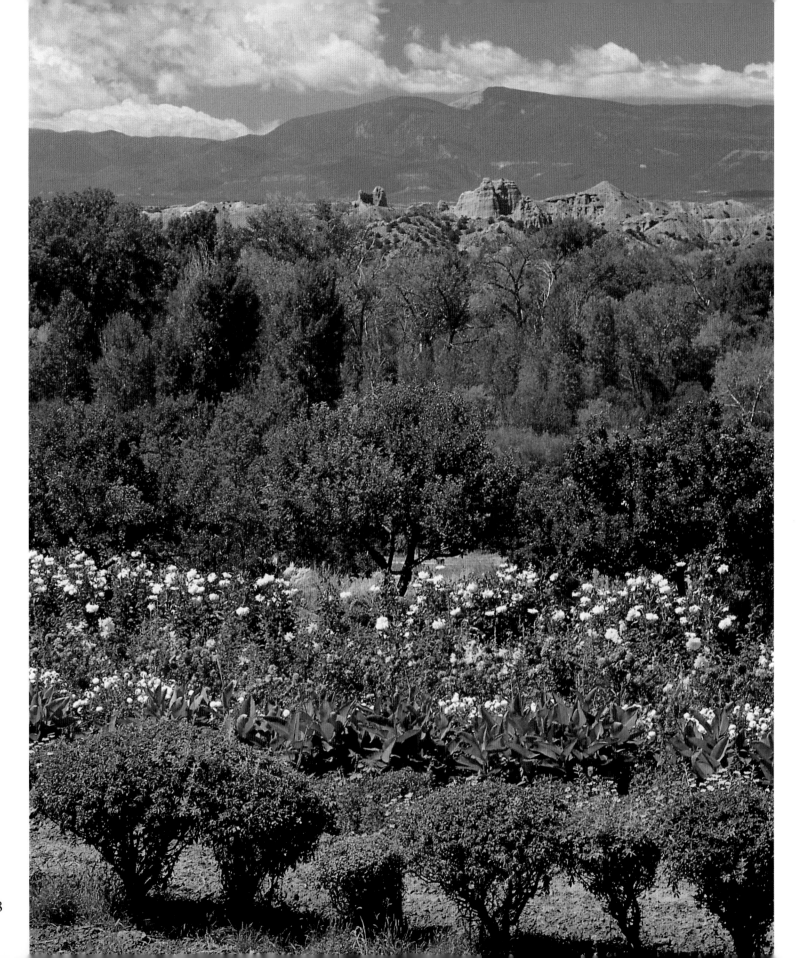

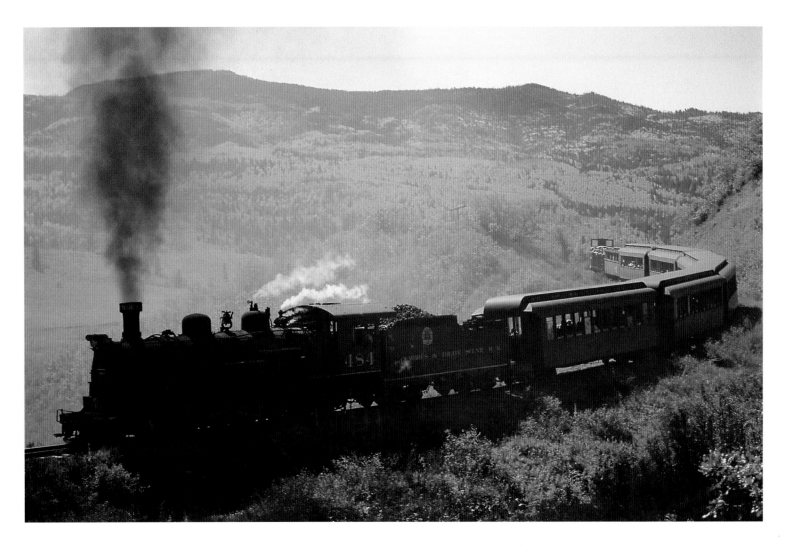

Sixty-four miles long, Chama's Cumbres and Toltec Scenic Railroad runs along North America's longest narrow-gauge track. Once an important freight route for the surrounding silver mines, the railway now carries visitors along the New Mexico–Colorado border.

New Mexico's cropland encompasses about 2.3 million acres, and pastureland accounts for another 42 million. In total, there are about 13,500 farms within the state.

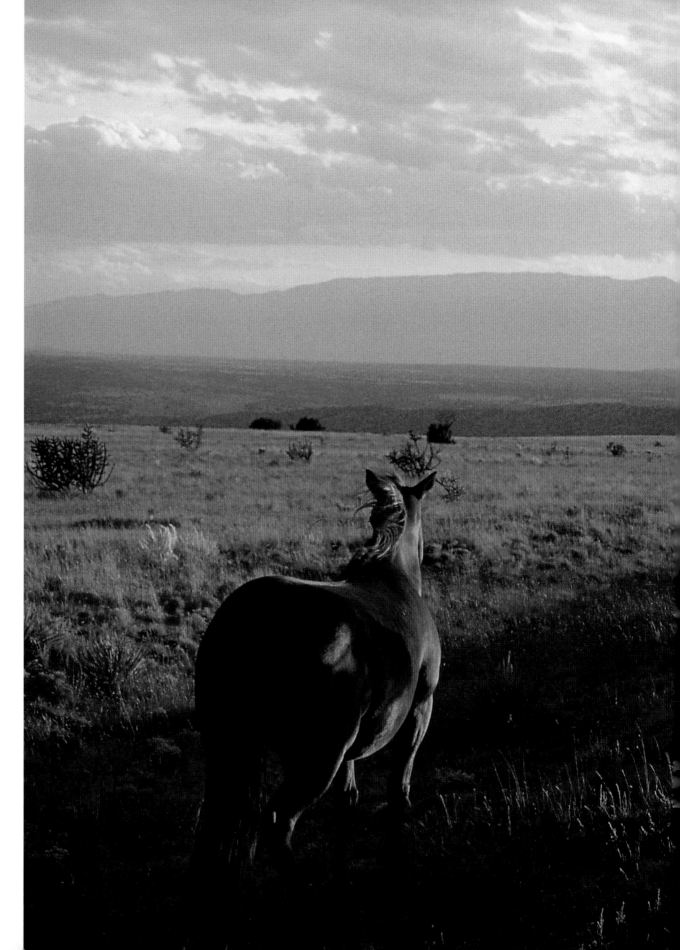

Francisco Vasquez de Coronado arrived in New Mexico on horseback in 1540, bringing the first horses into the area. Today, the horse remains an important part of the west. These wild horses attest to that legacy.

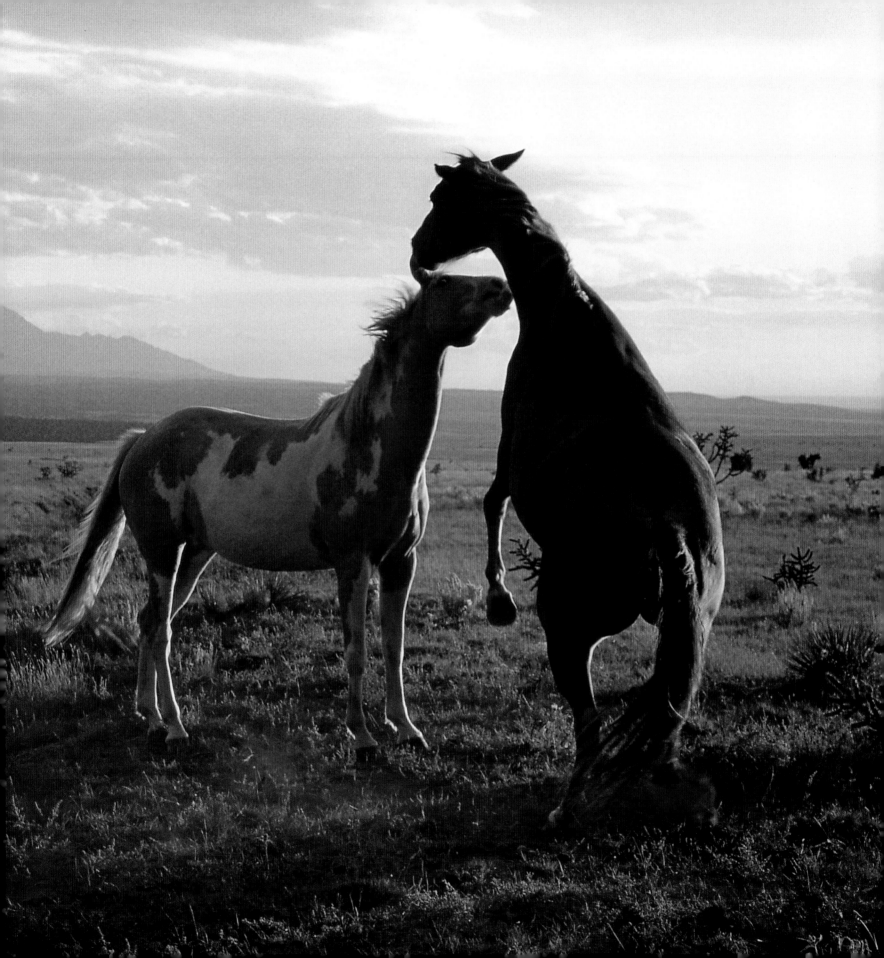

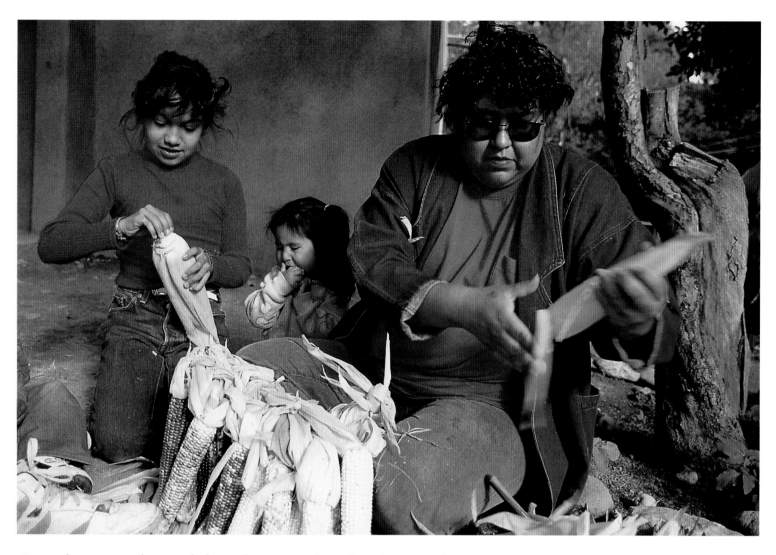

Corn, beans, and squash have been staples of native people in New Mexico for thousands of years. Some believe corn to be a sacred symbol of abundance and fertility.

Villanueva State Park provides a tranquil retreat just outside the town of Villanueva. Founded in 1808 by the Spanish, the settlement was surrounded by stone walls to fend off attacks by the local native people.

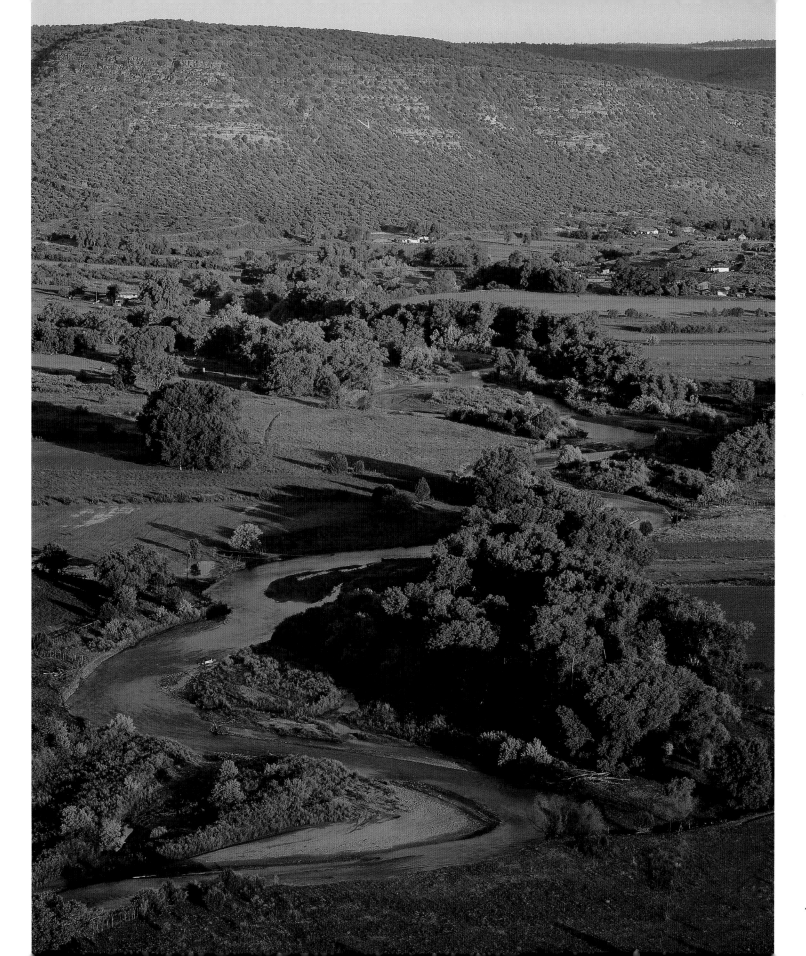

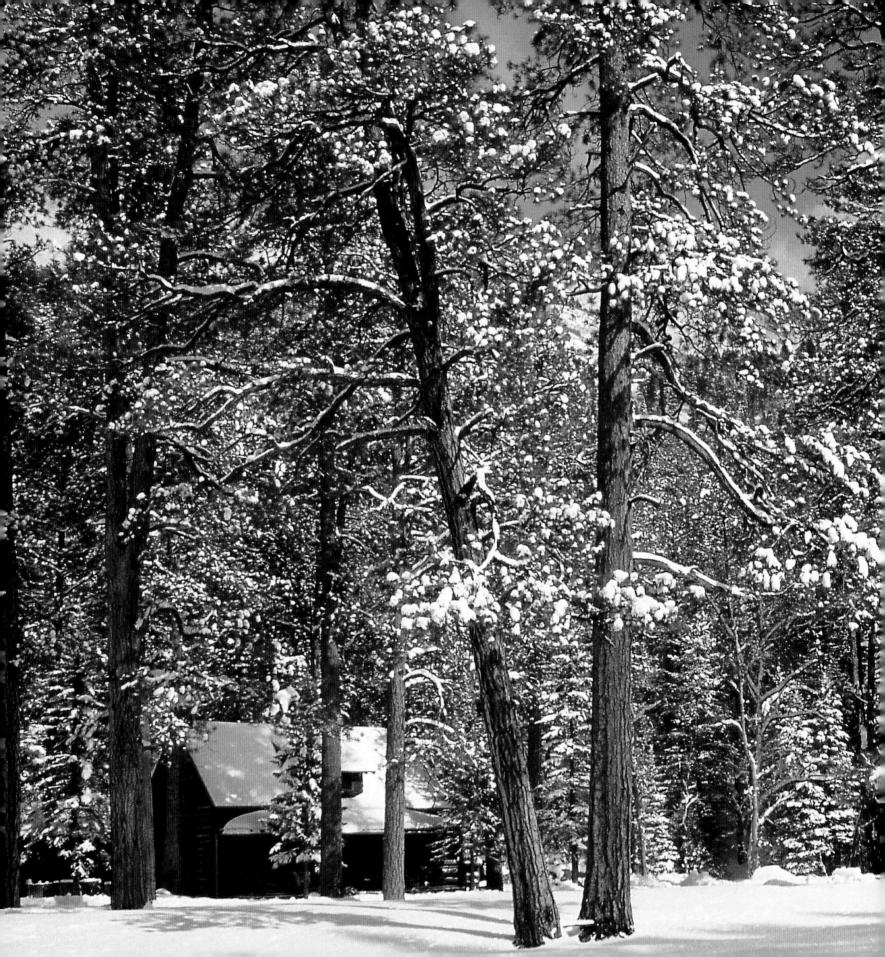

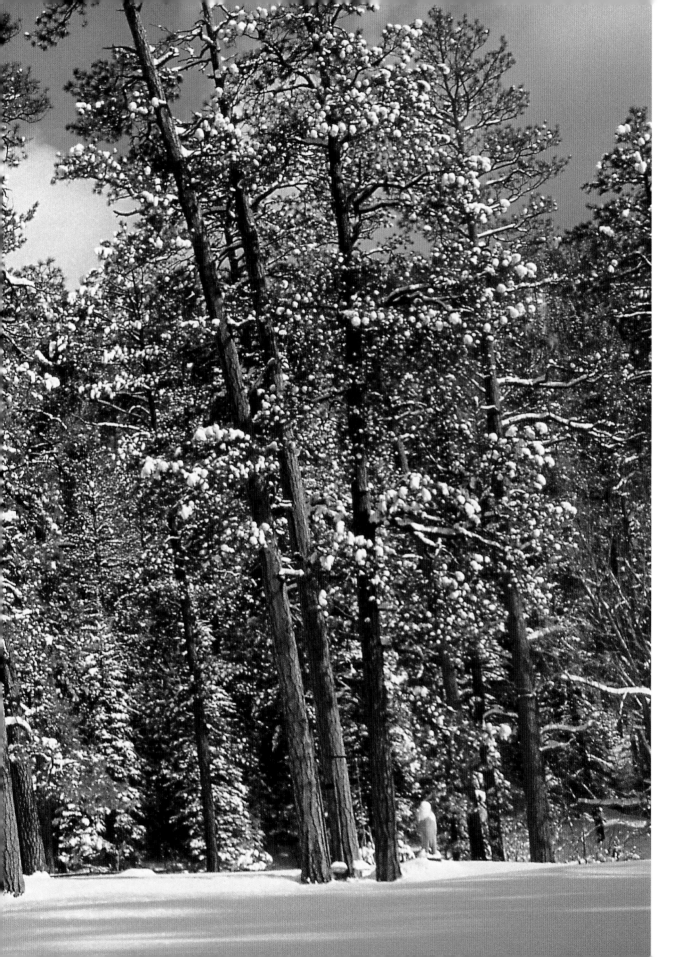

Snow blankets the woods of Pecos Wilderness Area. This remote forest offers hiking trails, campgrounds, and some of the best fishing in the region.

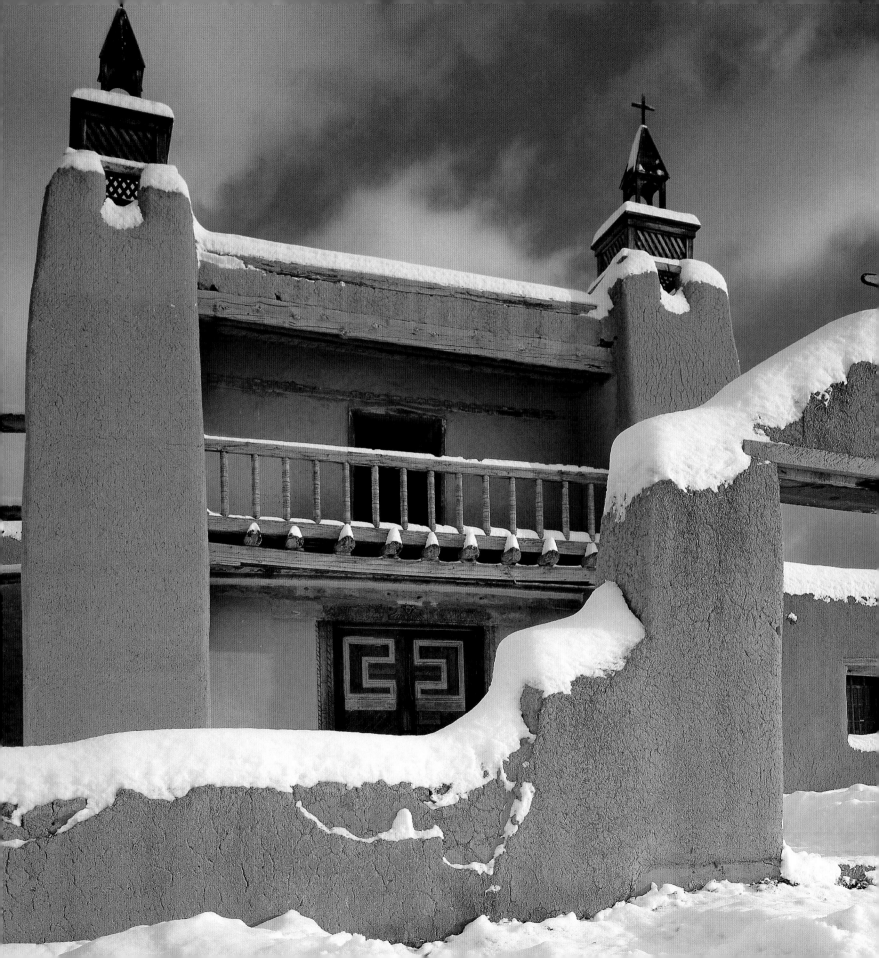

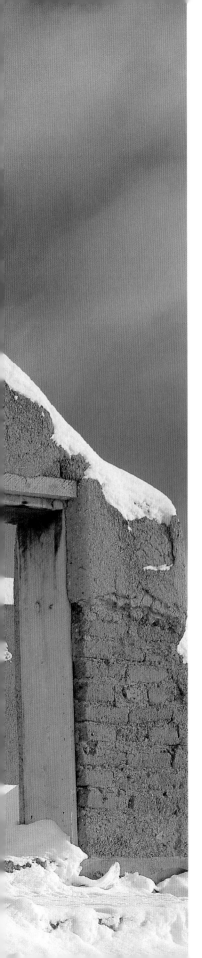

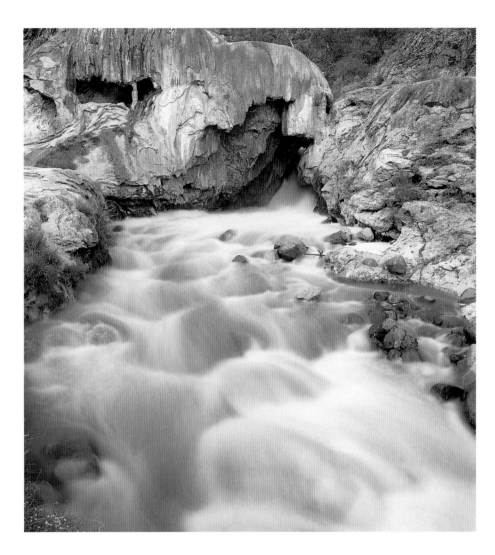

Swollen by spring runoff, a creek cascades through water-carved rocks in the Jemez Mountains. Several campgrounds in the area allow visitors to enjoy the pristine setting.

San José de Garcia is a Catholic church built by Spanish settlers near the town of Las Trampas in the 1700s. Its traditional Spanish architecture continues to draw visitors today.

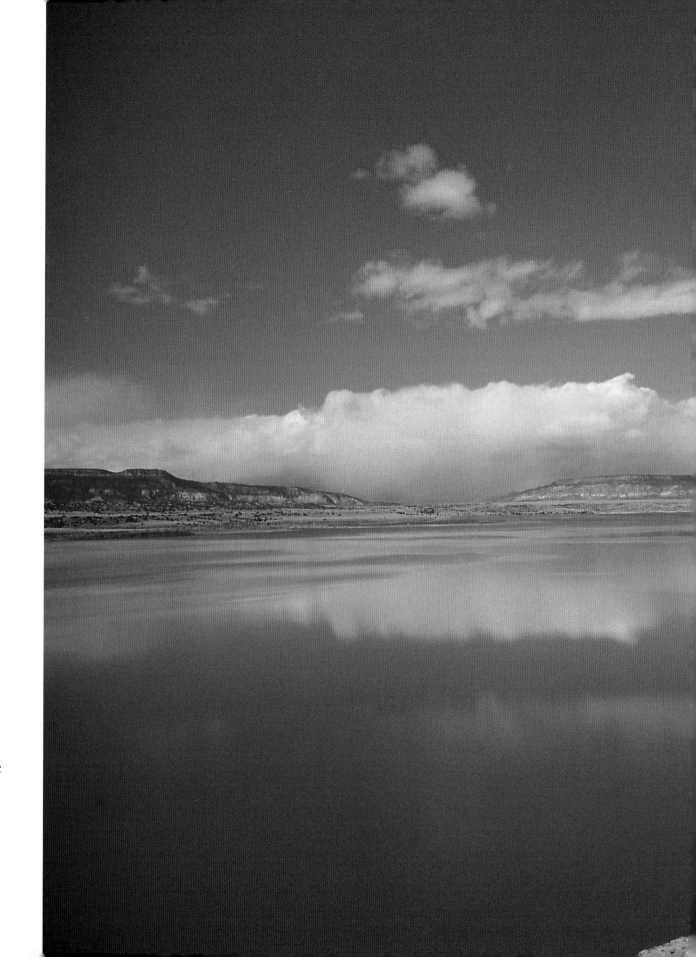

Abiquiu Reservoir
is a 4,000-acre lake
formed by the
damming of the
Rio Chama.

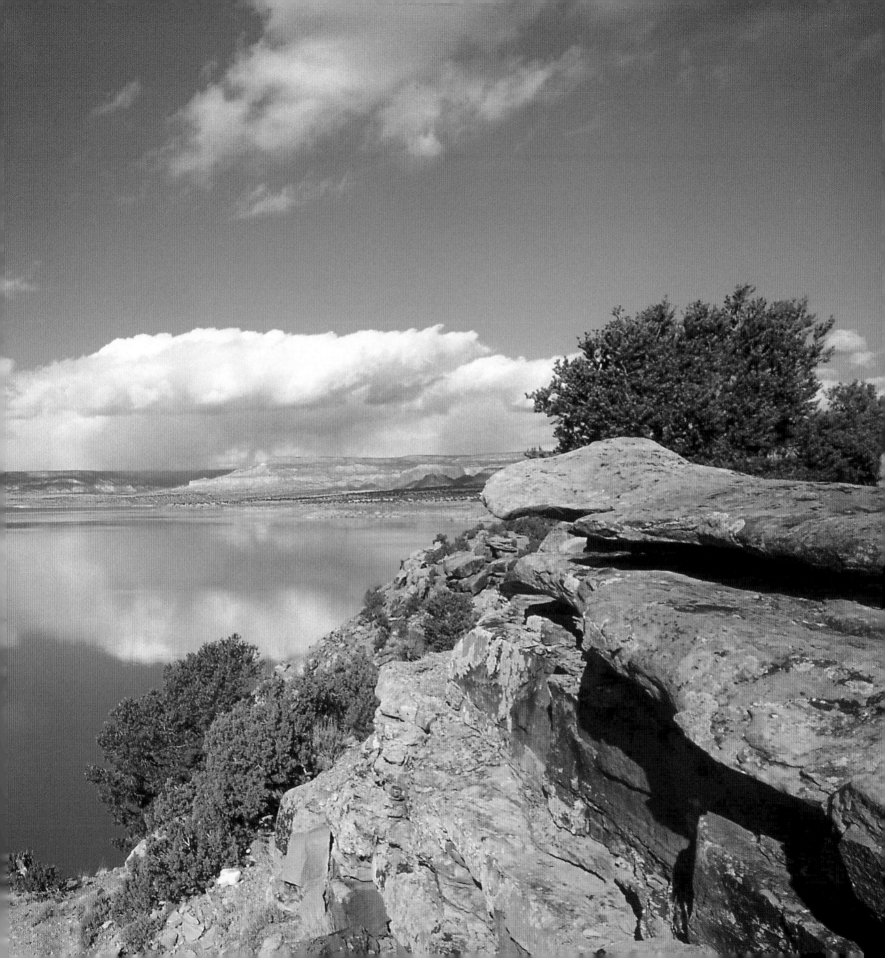

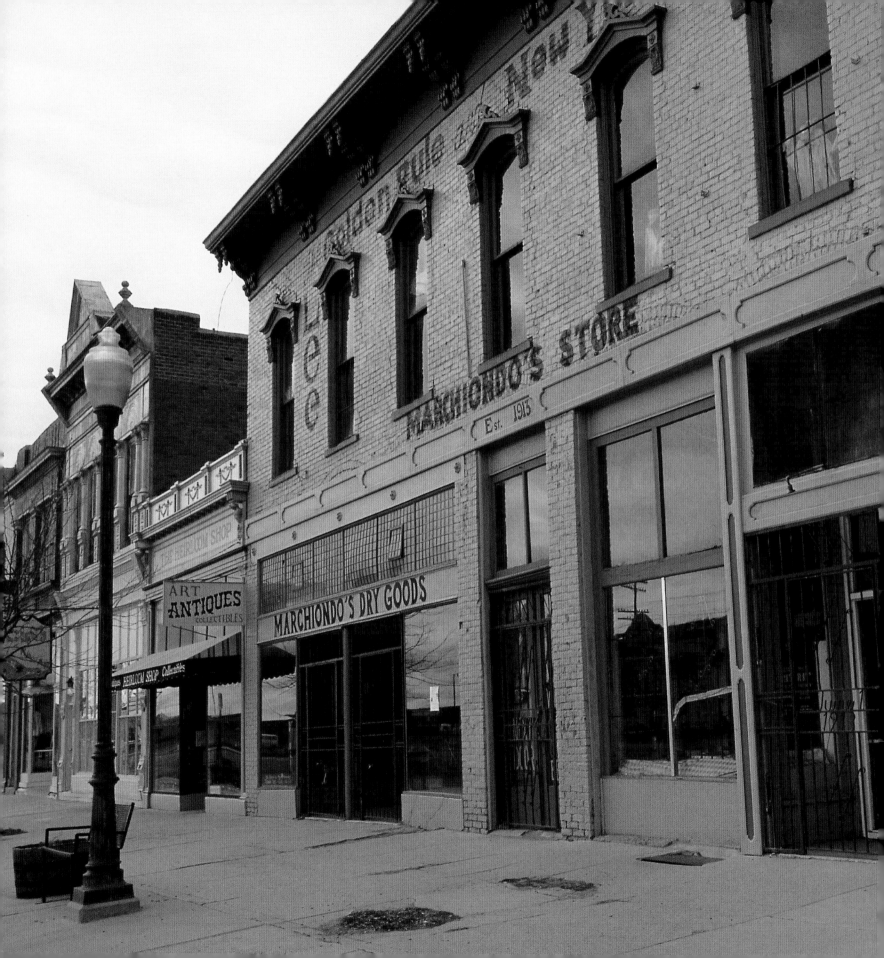

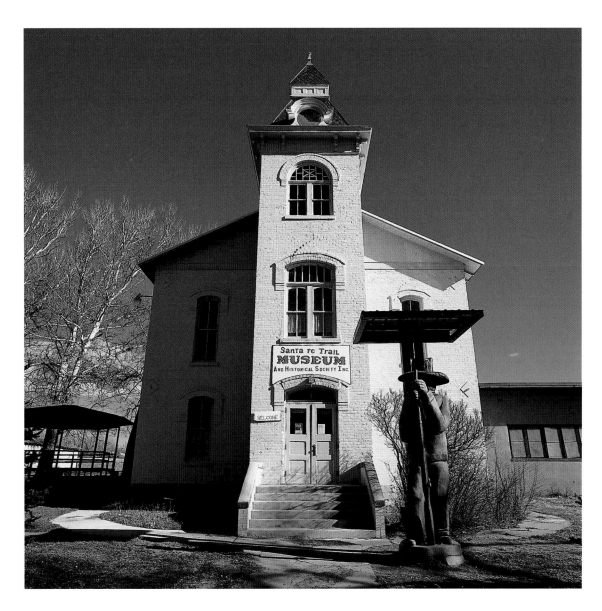

The Santa Fe Trail Museum in Springer takes visitors back to the 18th century, when traders gathered in Missouri each spring and fought their way for two months along the Santa Fe Trail. They sold their goods in New Mexico at up to a 500 percent markup.

Once a resting stop on the Santa Fe Trail, Raton is now a popular tourist destination, catering to hikers and skiers as well as history buffs, who come to tour the town's historic buildings.

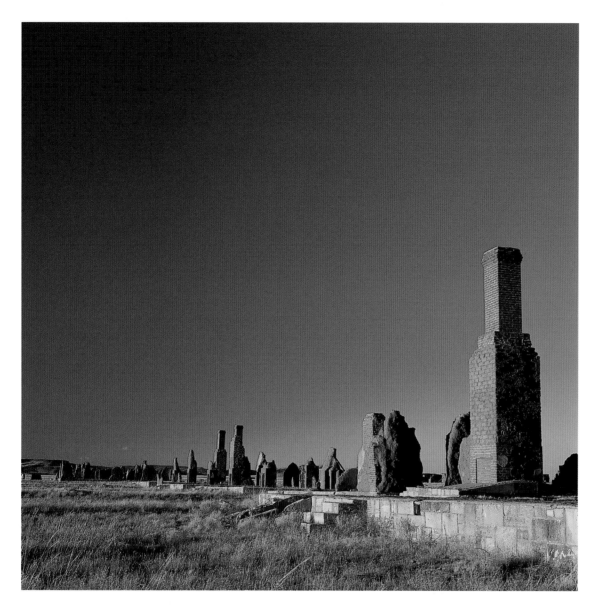

Once New Mexico's largest military headquarters, Fort Union was responsible for protecting travelers along the Santa Fe Trail. The Fort Union National Monument now preserves the ruins of the post.

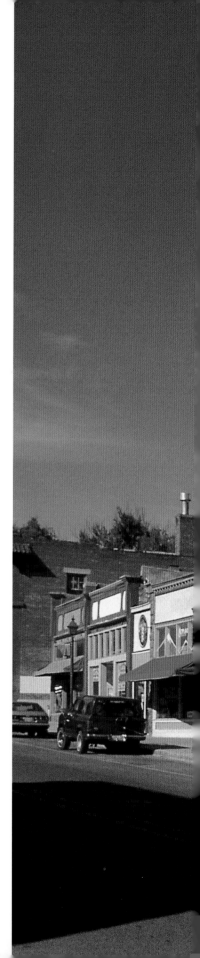

In its 200-year history, Las Vegas has been a base for ranching, a military headquarters, and, with the arrival of the railway, a commercial center. It is now a town of 15,000, boasting a well-preserved historic district.

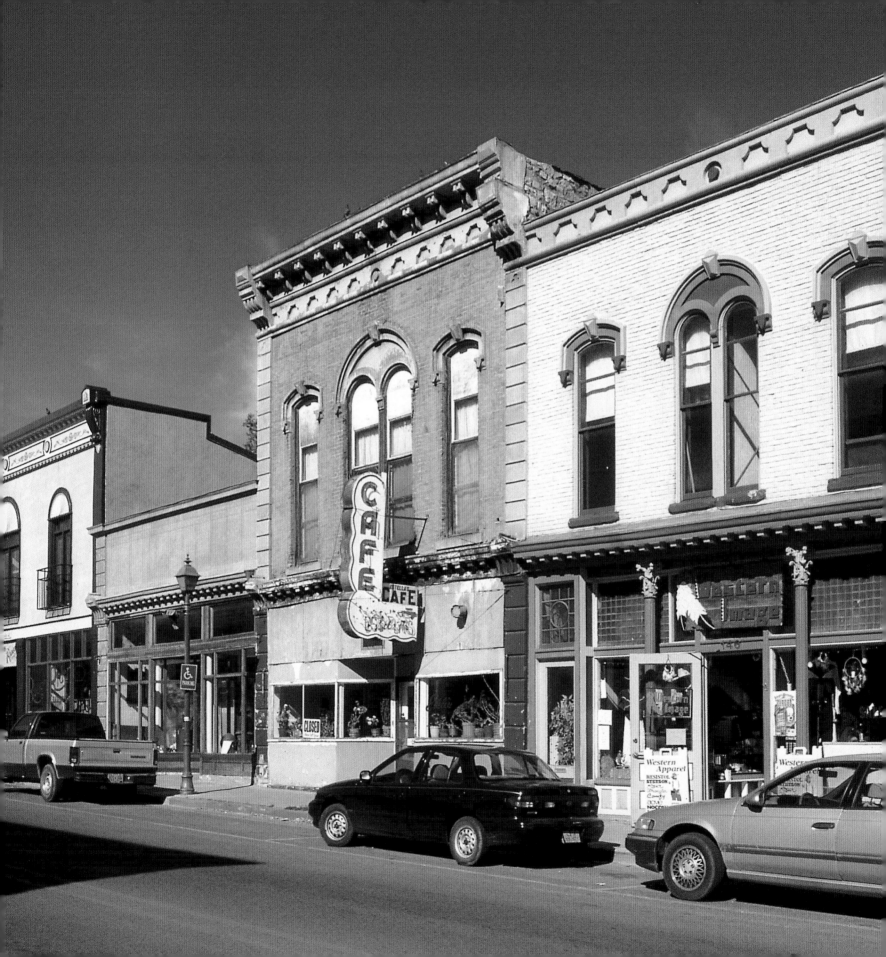

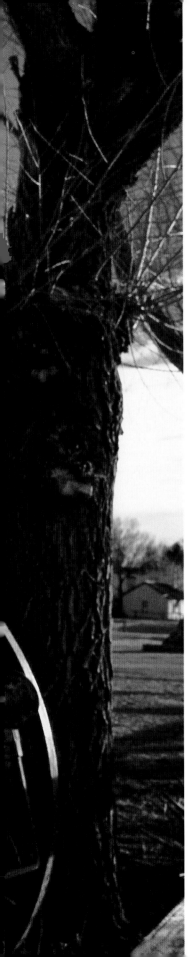

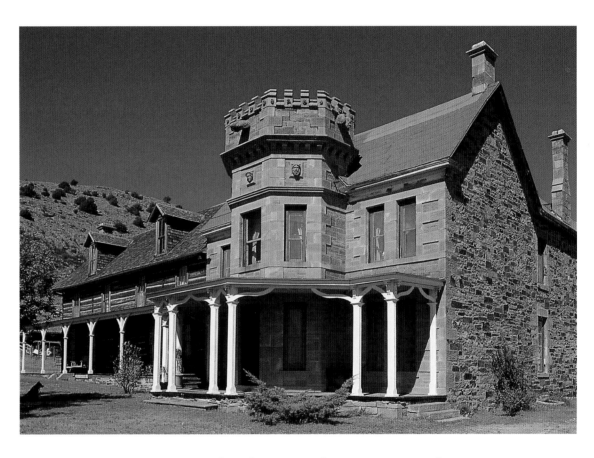

Dorsey Mansion was completed in 1886 by Senator Stephen W. Dorsey. The sprawling residence boasted a pool, rose gardens, a tower, and a greenhouse. It was protected as a state monument in 1976.

The plains town of Cimarron has a long history of farming and ranching, preserved by the Old Aztec Mill Museum. Visitors can wander around an old grist mill or imagine the days when settlers used the traditional farming equipment, sleighs, and wagons on display.

Albuquerque boomed with the arrival of the railway in the late 19th century. It continues to be a major center for transportation and trade, and is home to one-third of New Mexico's population.

Trade Winds
MOTOR HOTEL

VACANCY

YOURS WITH THE SOUTHWEST'S FINEST

SATELITE	HBO	SGL	96
COLOR TV	FREE	DBL	96
		WKLY	0
PHONE	MOVIES	MTHLY	250

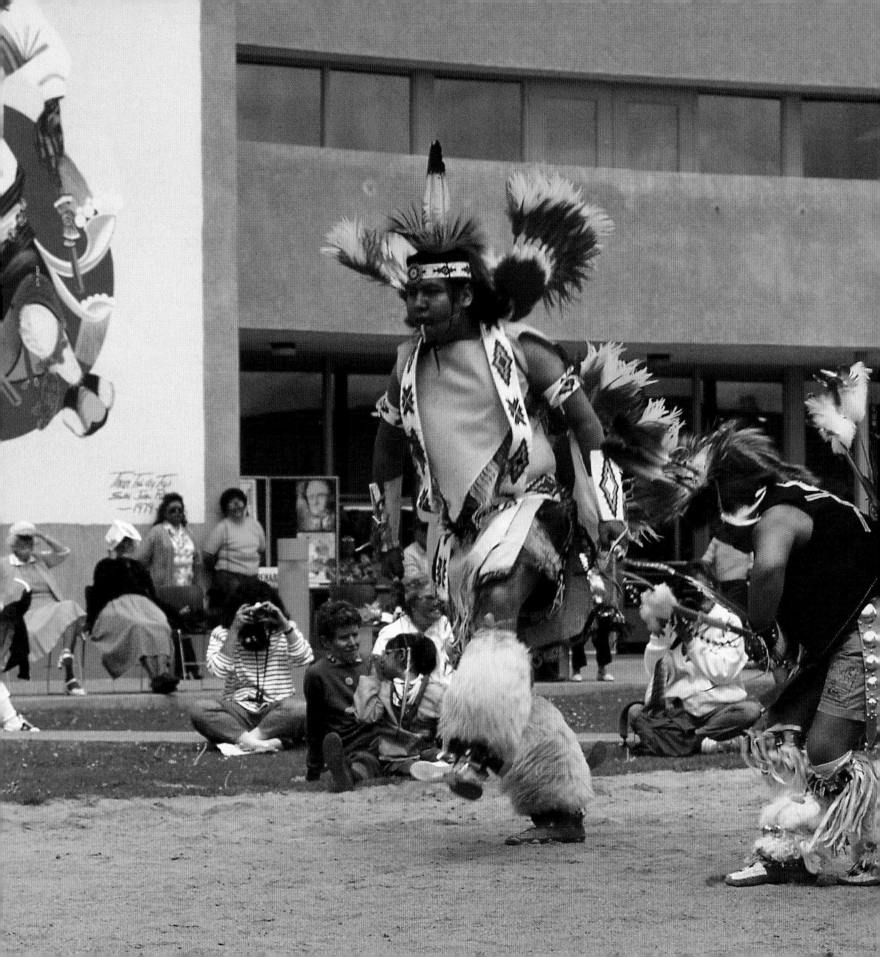

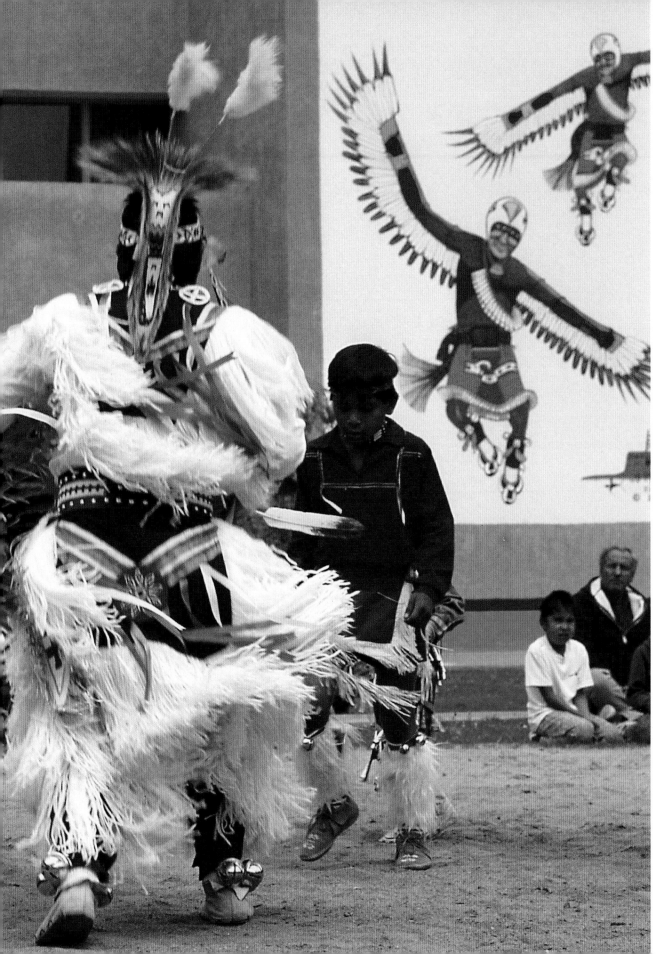

At the Indian Pueblo Cultural Center, performers showcase a traditional dance. The museum is owned by New Mexico's 19 pueblos, and highlights the history, artwork, and traditions of the state's native people.

59

The world's longest aerial tramway whisks sightseers up a breathtaking 2.7 miles to Sandia Peak.

<small>OPPOSITE—</small>
More than 600 balloons rise above Albuquerque each October, during the city's annual International Balloon Fiesta. The event attracts more than 700,000 enthusiasts.

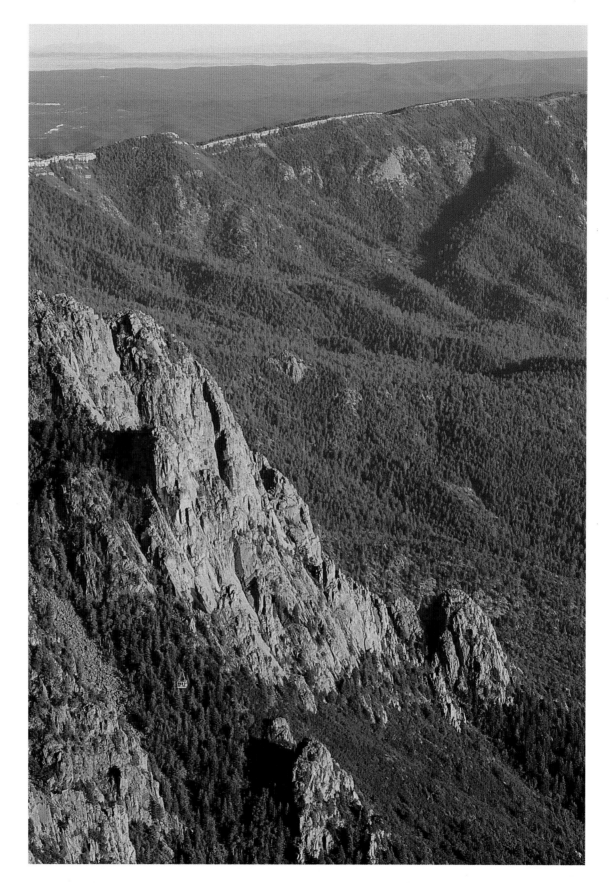

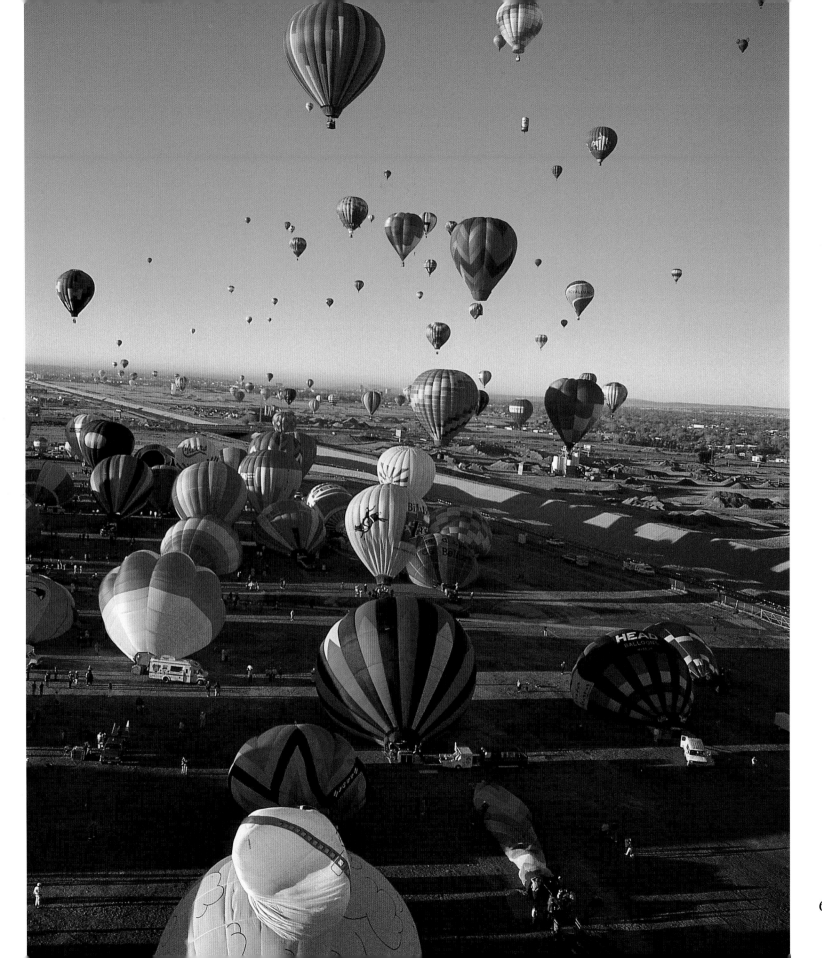

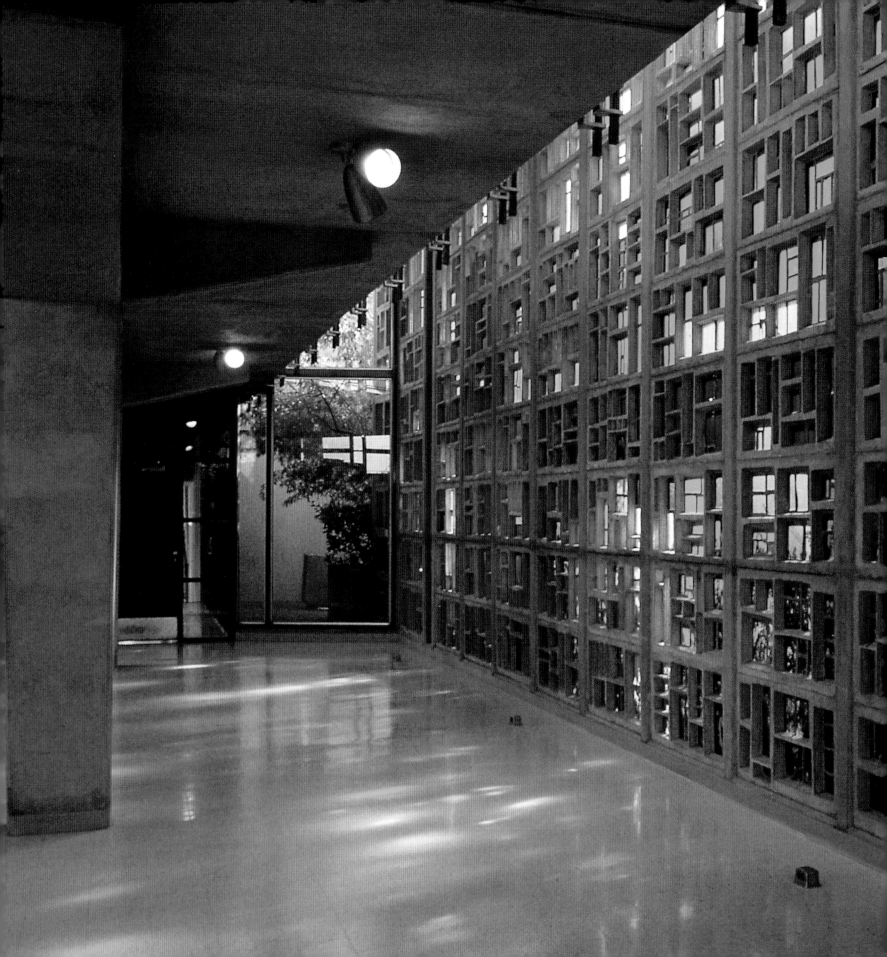

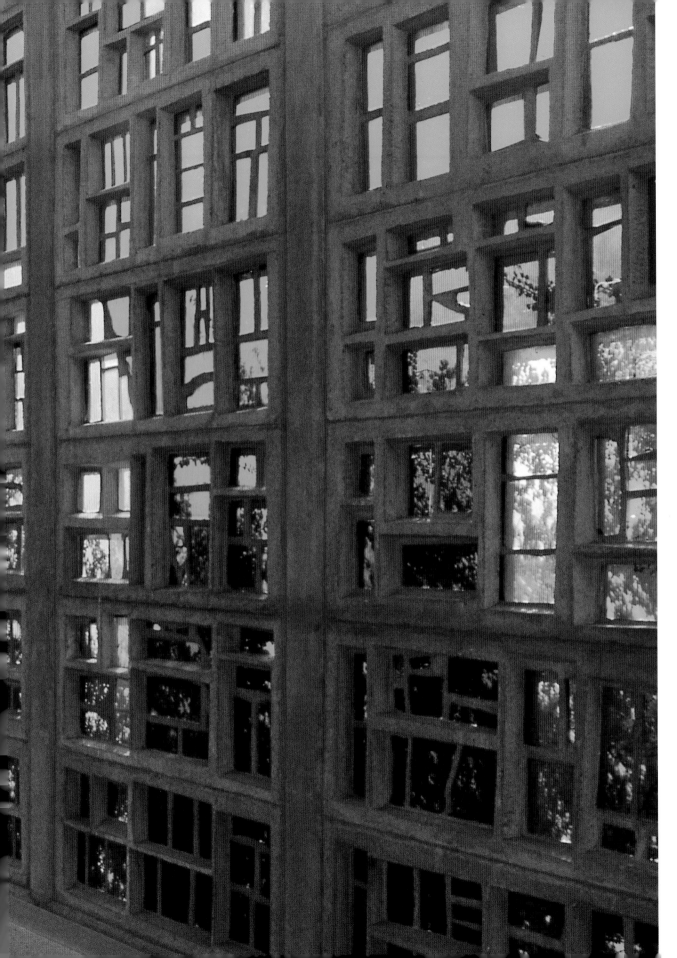

The state's largest post-secondary institution, the University of New Mexico, offers courses to more than 30,000 students on five campuses. The 170 buildings on its main campus in Albuquerque include six libraries and an observatory.

Albuquerque's Hispanic Celebration of the Fourth of July commemorates the city's heritage. Numerous fireworks displays throughout the city also add an air of celebration to the day.

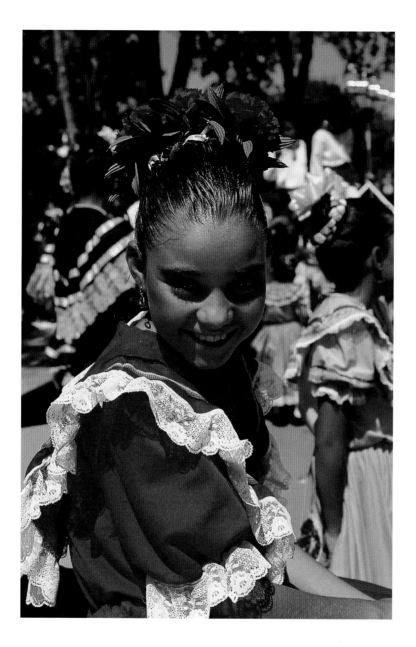

Visitors try their luck at the New Mexico State Fair, held each September. This is one of the largest state fairs in the country, and festivities include a carnival, a rodeo, and live entertainment.

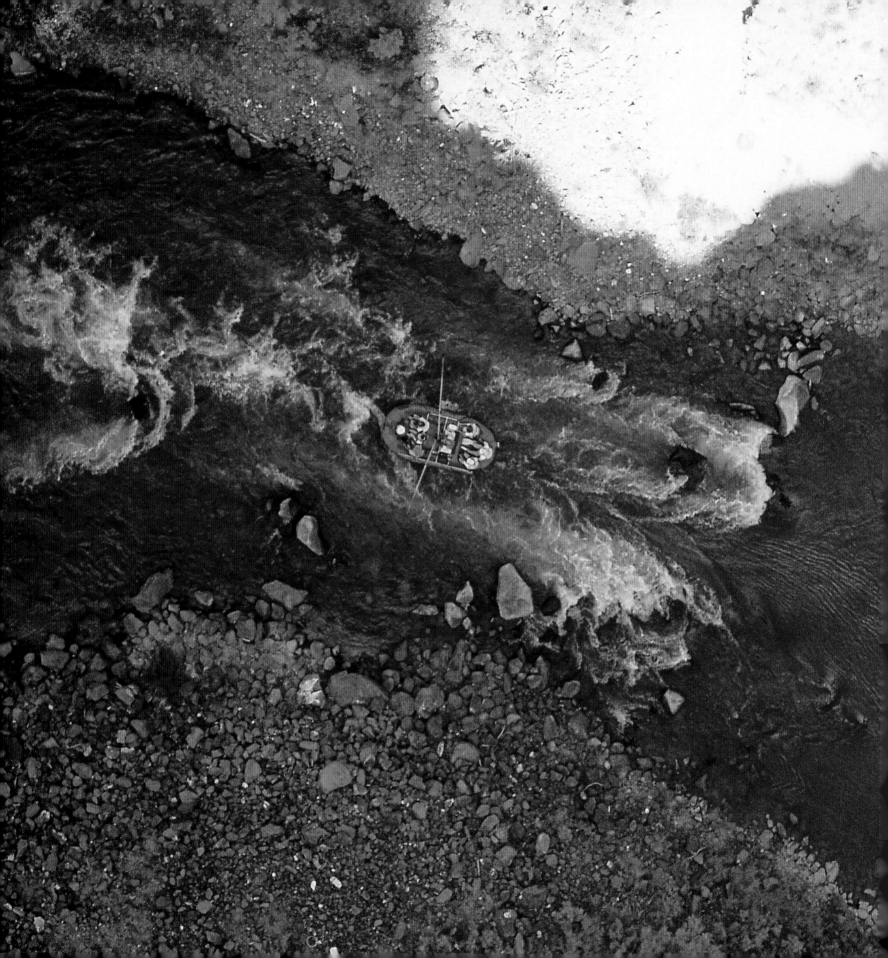

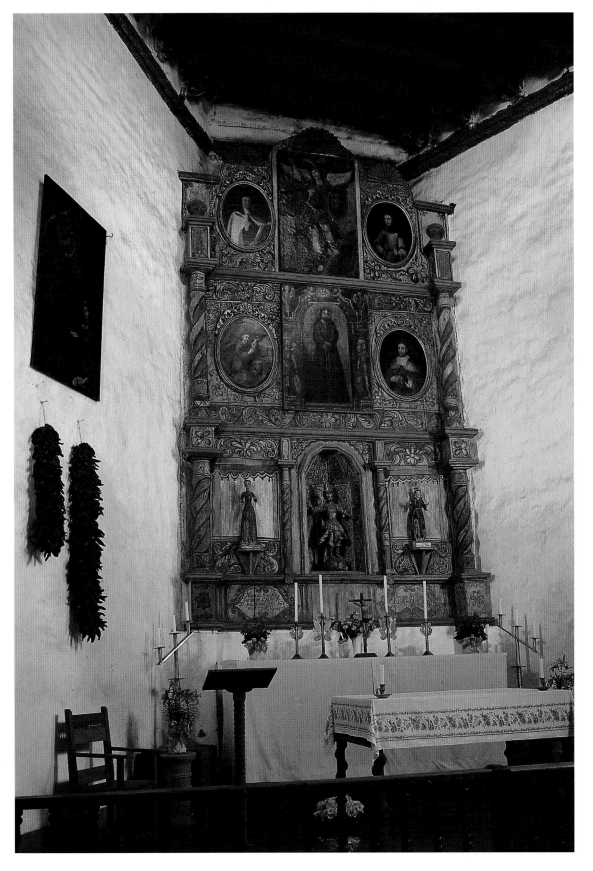

Mission of San Miguel of Santa Fe was built in 1610 and is the oldest mission in the country. It was partially rebuilt in the early 18th century after it was damaged in the Pueblo Revolt of 1680 against the Spanish.

OPPOSITE—
Rafters experience the thrill of floating down the Rio Grande. The fifth-largest river in the world, the Rio Grande runs through New Mexico for about 470 miles on its route to the Gulf of Mexico.

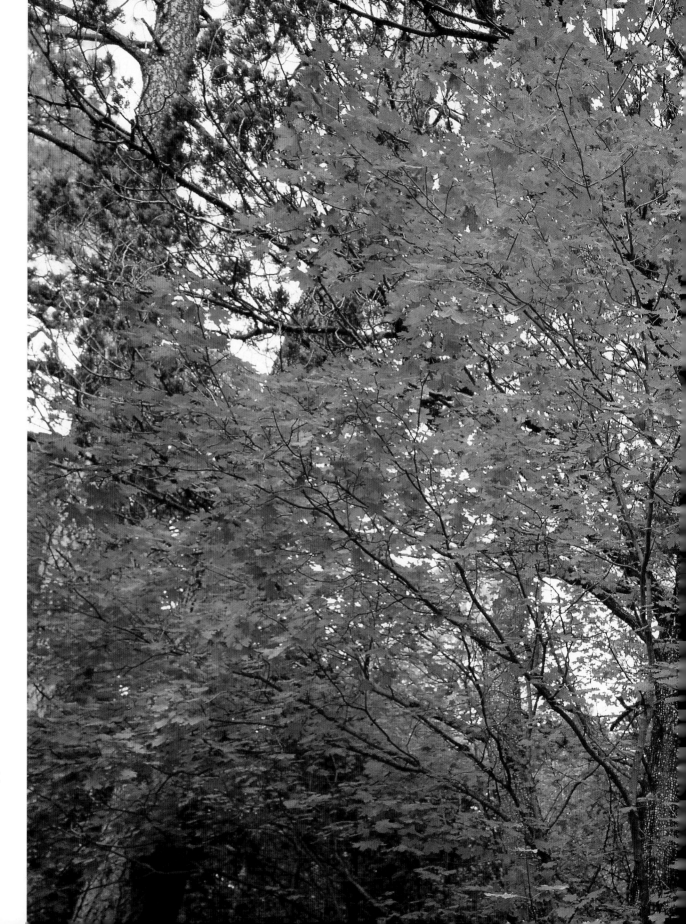

Bigtooth maples add a splash of color to the Manzano Wilderness, south of Albuquerque. Nearby, Manzano Mountains State Park offers camping facilities and hiking trails.

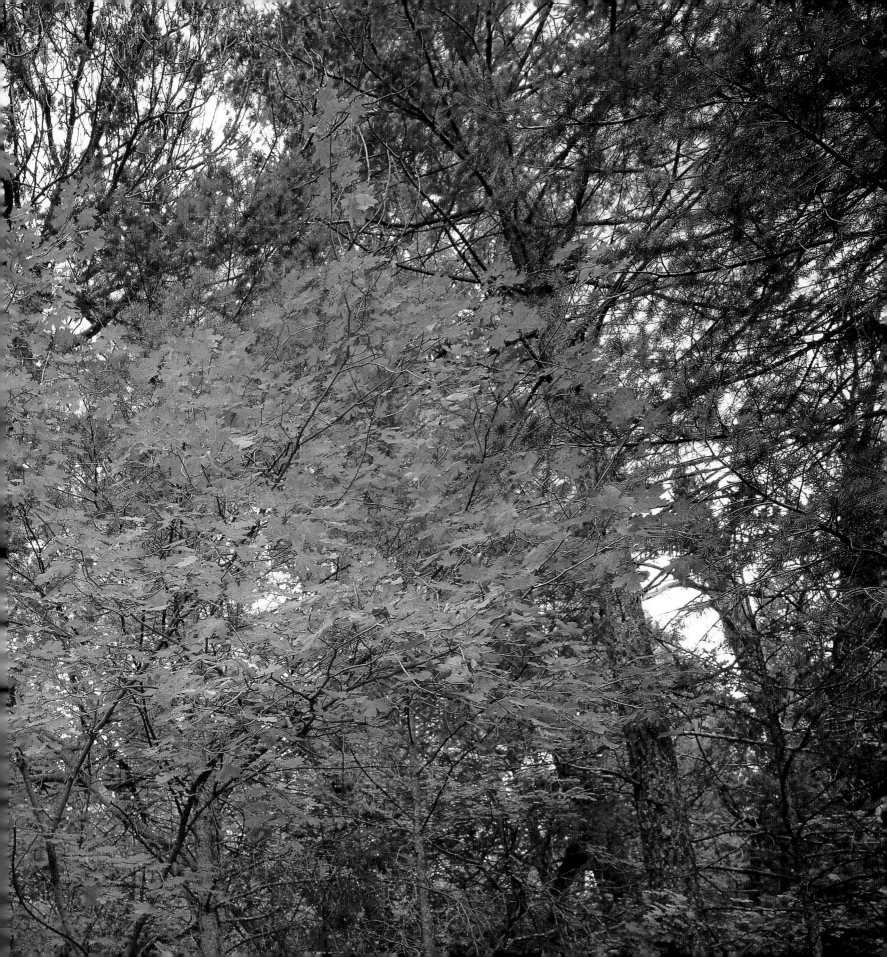

An arts and crafts fair in Santa Fe's plaza showcases distinctive pottery each summer.

OPPOSITE—
Home to more than 65,000 people, Santa Fe is known for its high population of artists and performers, and its relaxed atmosphere. The city's plaza has remained essentially unchanged for 400 years.

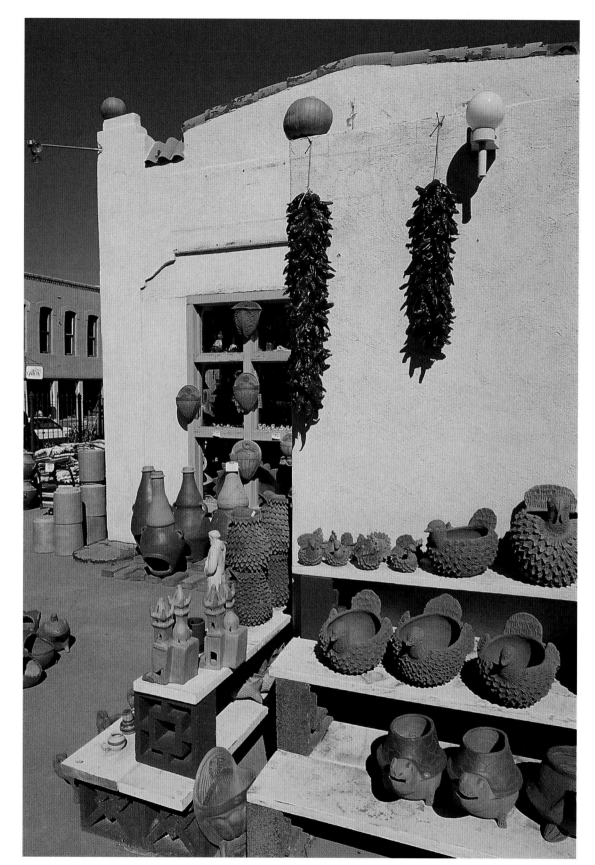

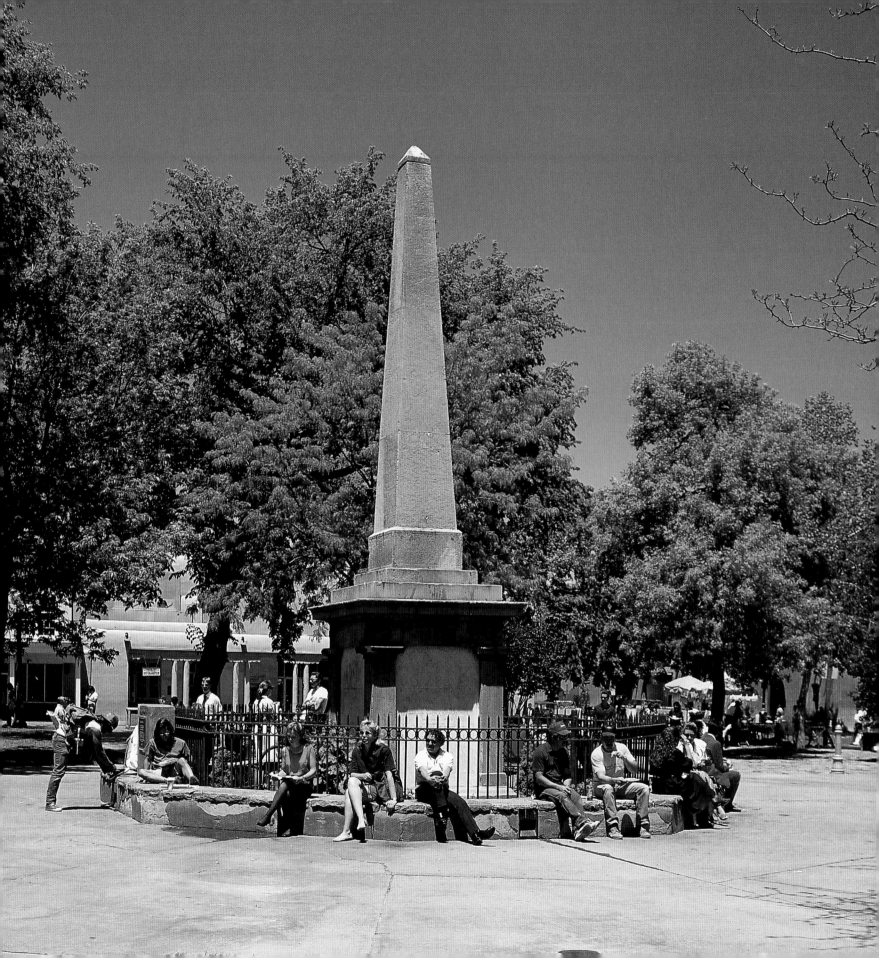

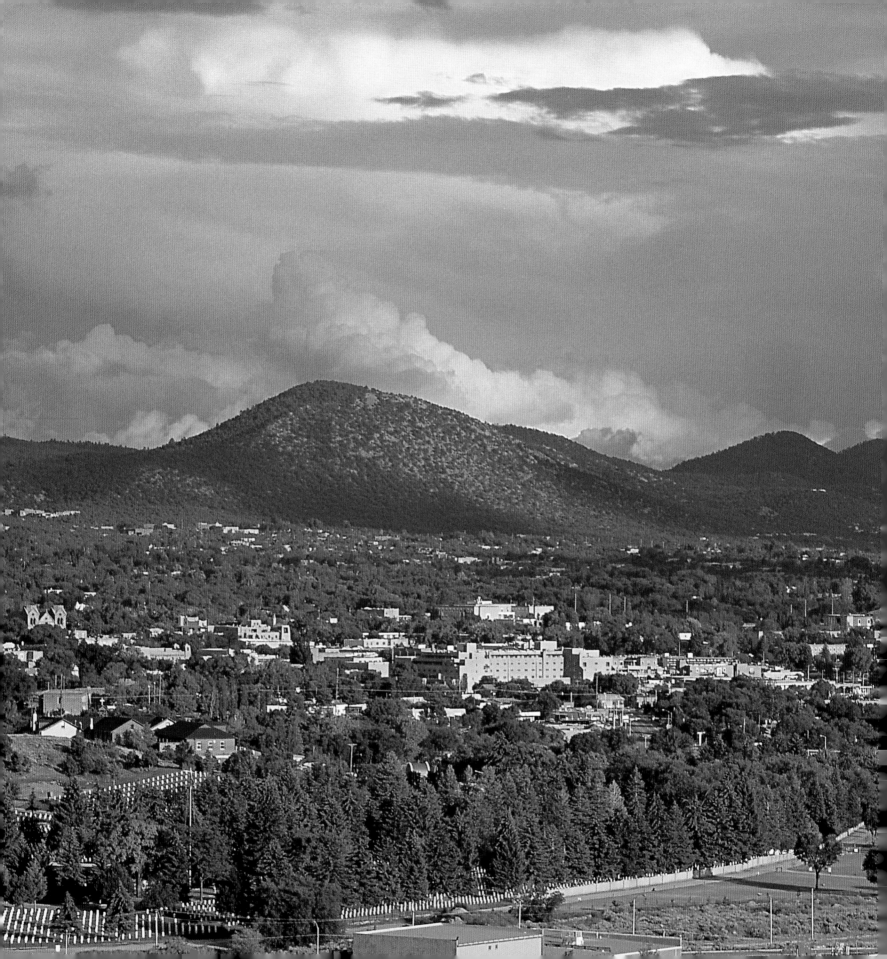

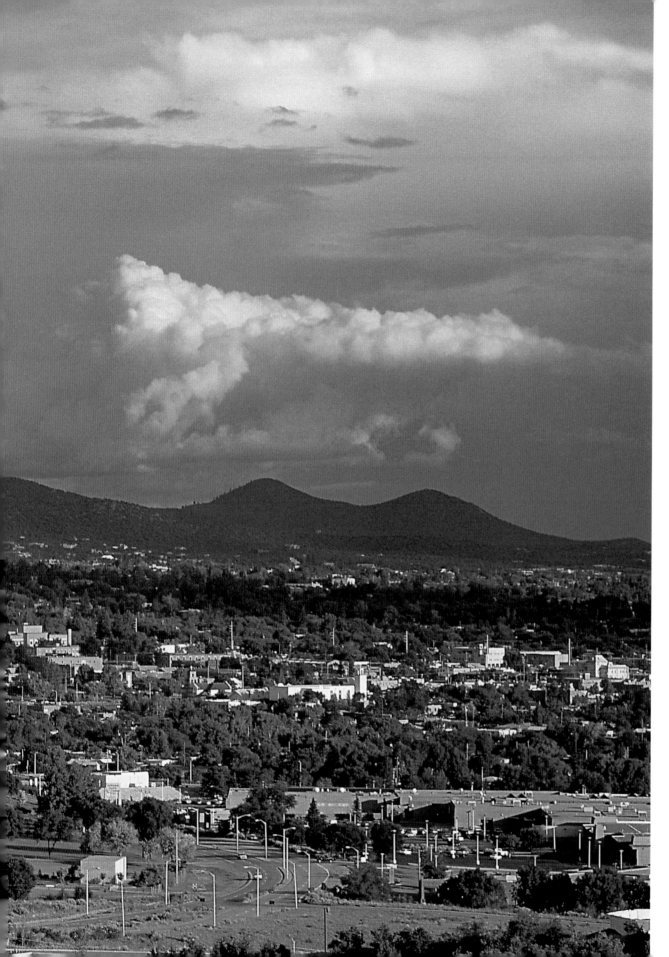

Santa Fe boasts more than 300 days of sunshine each year. Tourists flock to the city in summer for the array of cultural activities and in winter for the skiing.

America's oldest state capital, Santa Fe was founded by New Mexico governor Don Pedro de Peralta in 1610. The city became the capital of the territory when New Mexico was claimed for the United States in 1846, during the Mexican War.

The Cathedral of St. Francis of Assisi is dedicated to Santa Fe's patron saint. It was built in 1869 by Archbishop Jean-Baptiste Lamy, a French immigrant to New Mexico, and was the first church in New Mexico to gain cathedral status.

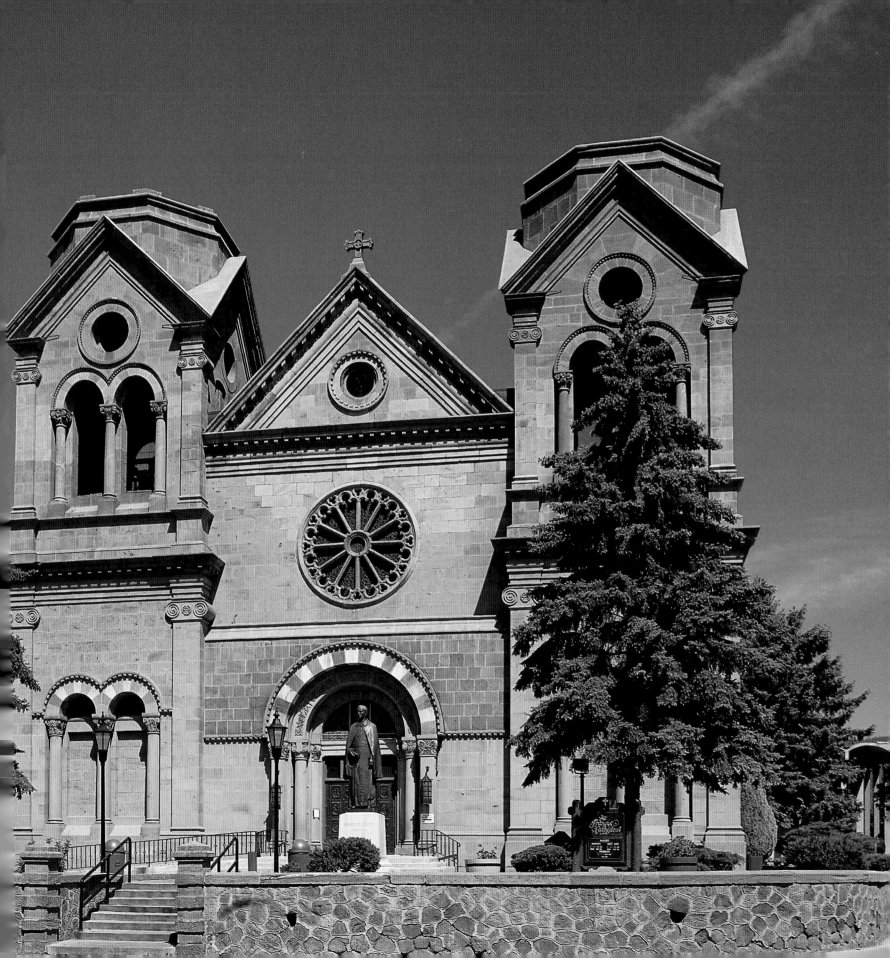

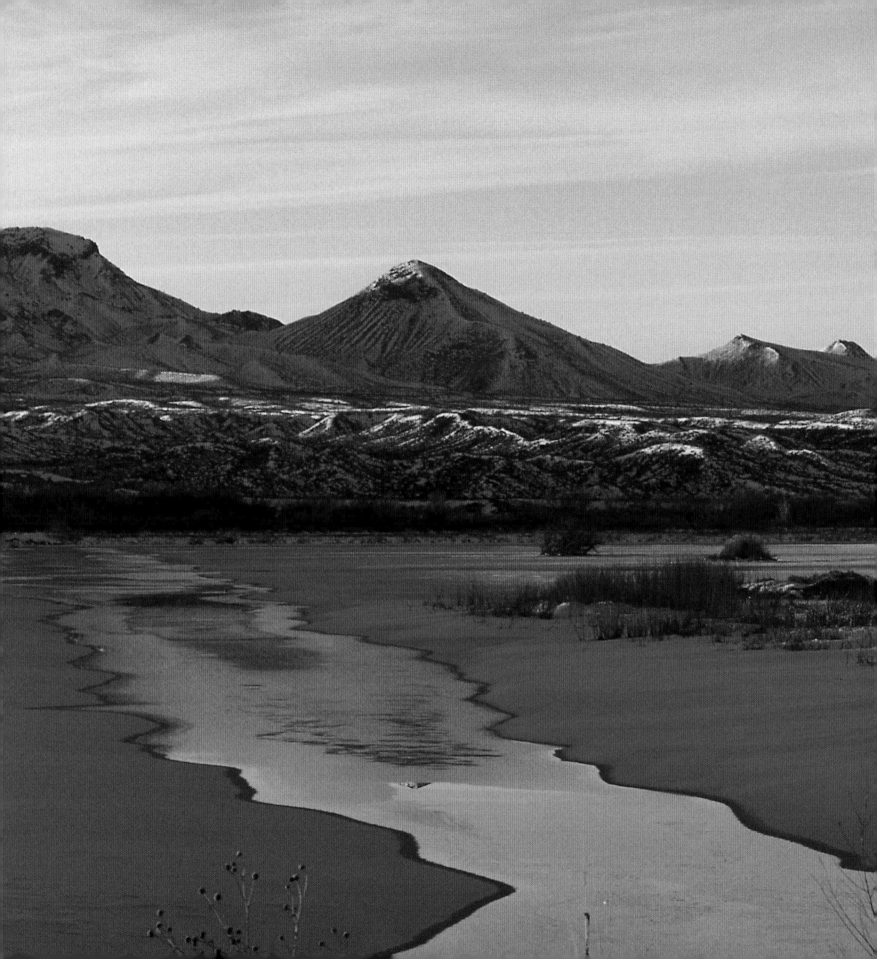

South of Socorro, Bosque del Apache National Wildlife Refuge is the wintering grounds for 300 bird species, including more than 12,000 sandhill cranes. Farmers who work the refuge land during the summer leave a portion of their crops behind for the birds.

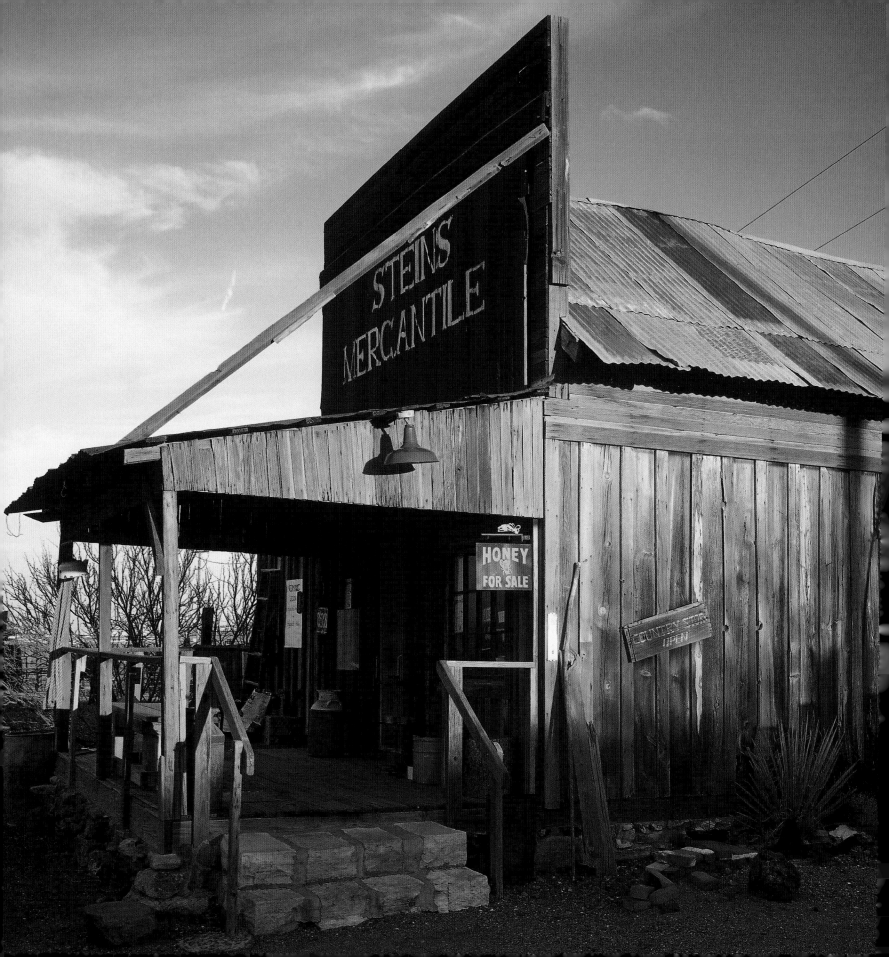

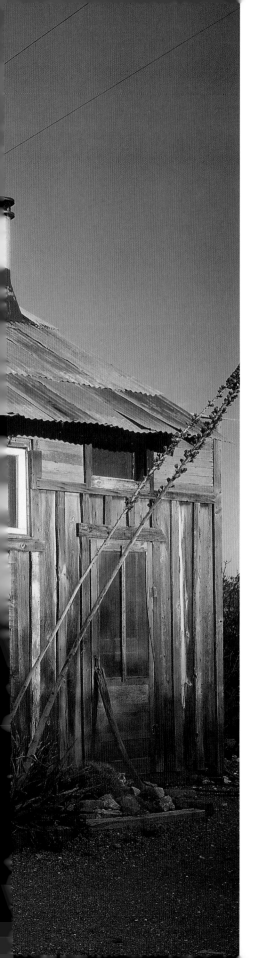

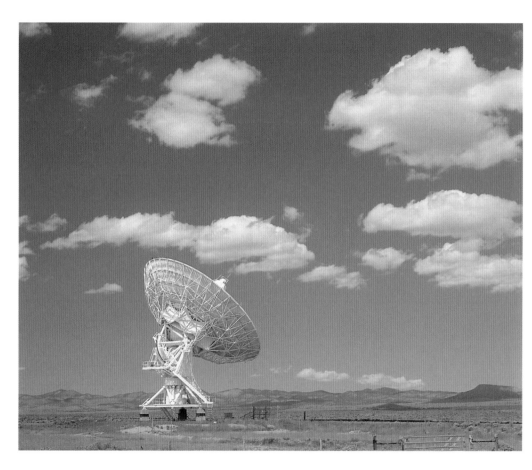

Appropriately named, the Very Large Array radio telescope consists of 27 antennae, each 82 feet in diameter, 94 feet tall, and weighing 235 tons. The telescope is used to study the sun, other stars, and the planets.

Steins Mercantile served the passengers and workers of the Southern Pacific Railway in the late 19th century. The first transcontinental route through New Mexico was established in 1881, when the South Pacific line met the Santa Fe.

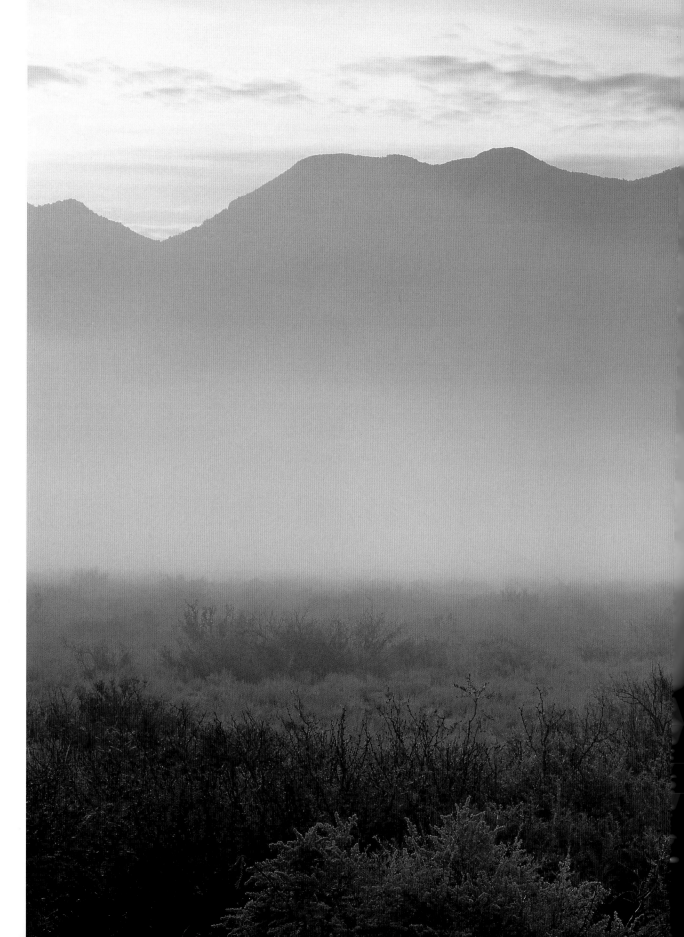

Created in 1926 as a refuge for the endangered desert bighorn sheep, Big Hatchet Wildlife Area encompasses more than 100,000 acres. Along with the bighorns, it is home to rare birds, mountain lions, coyotes, and a variety of small mammals.

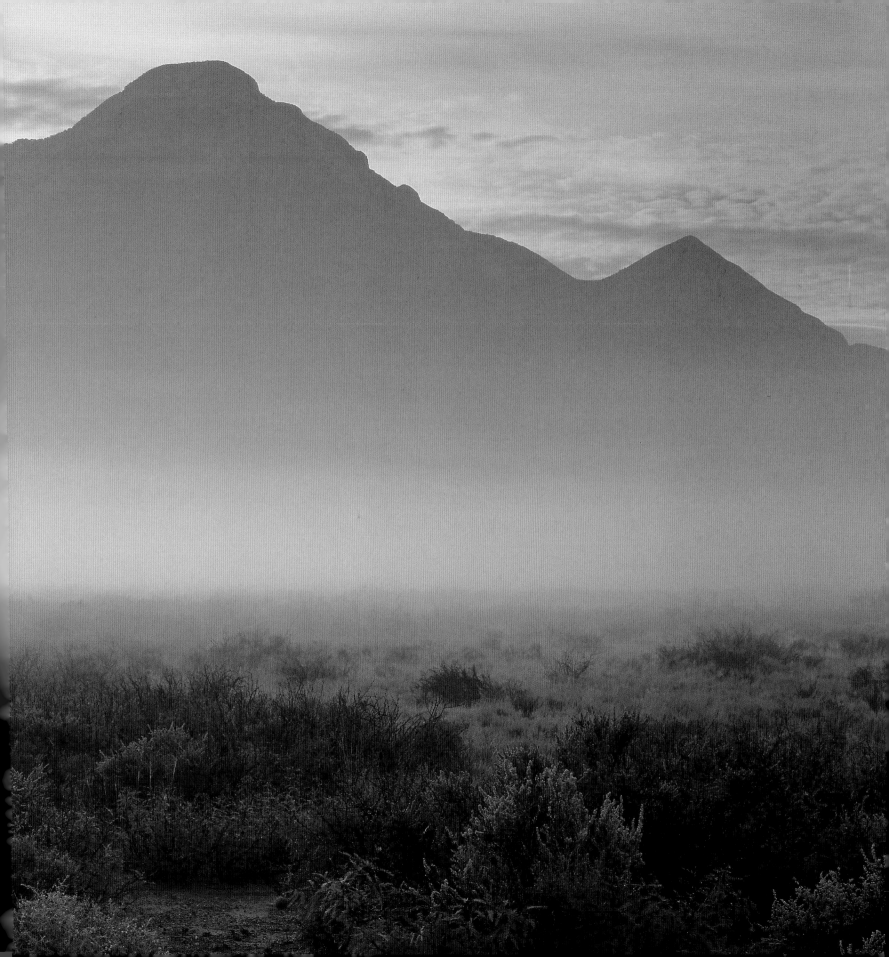

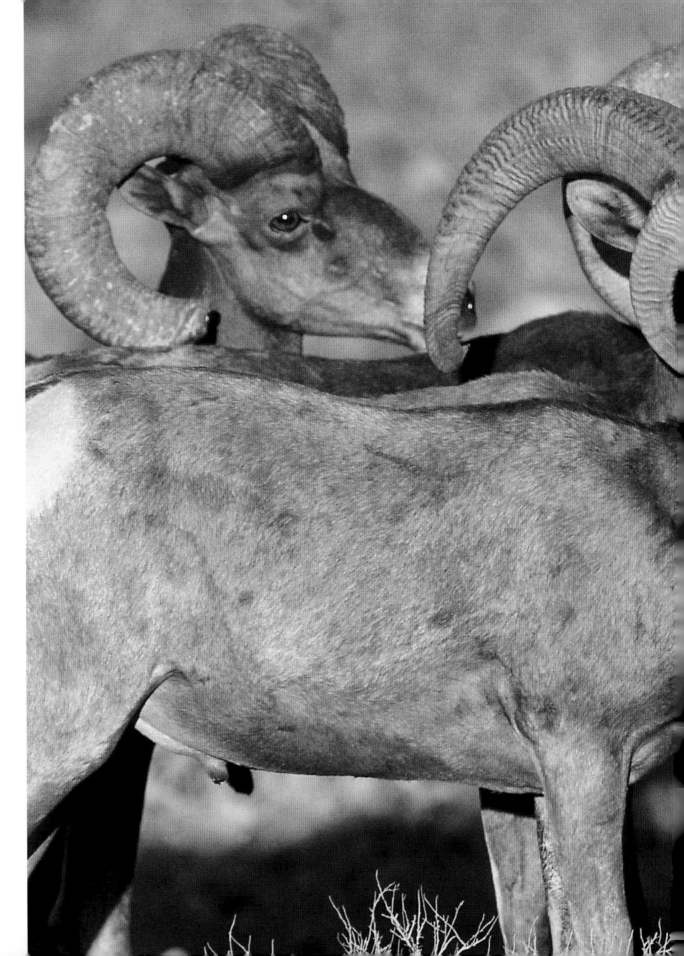

Desert bighorn sheep like these manage to survive in New Mexico's arid climate, along with the larger mountain bighorns. Decimated with the arrival of the Europeans, the populations of these animals are now slowly beginning to recover.

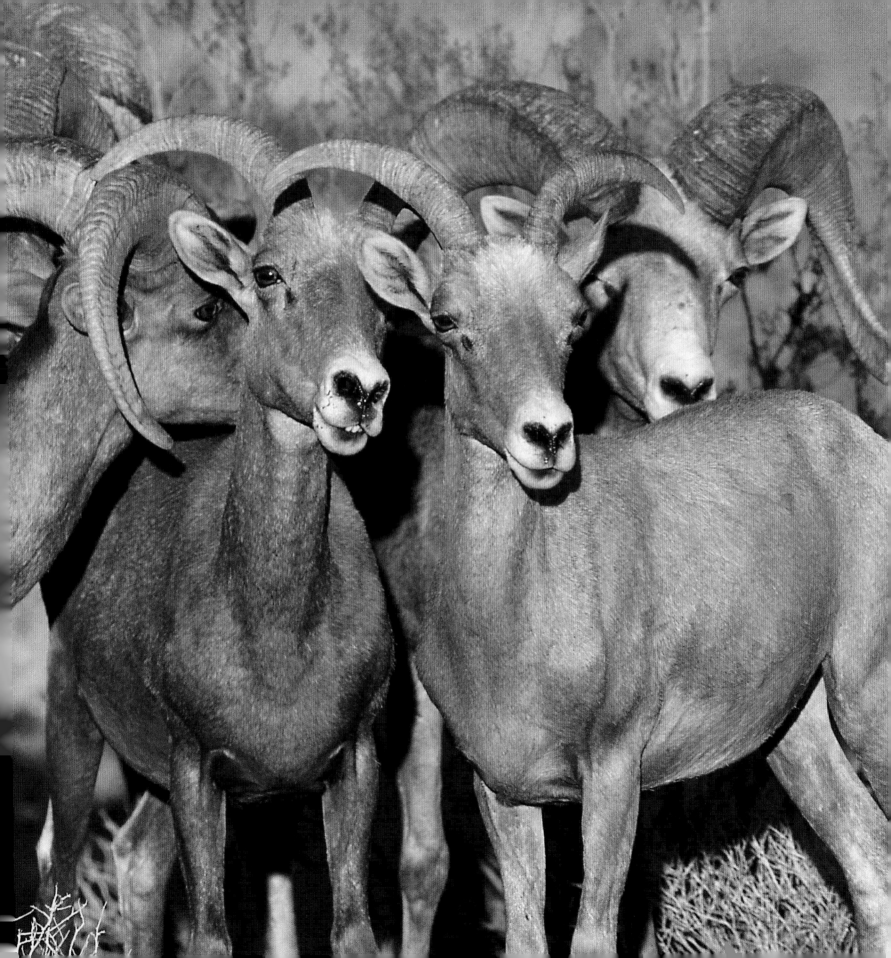

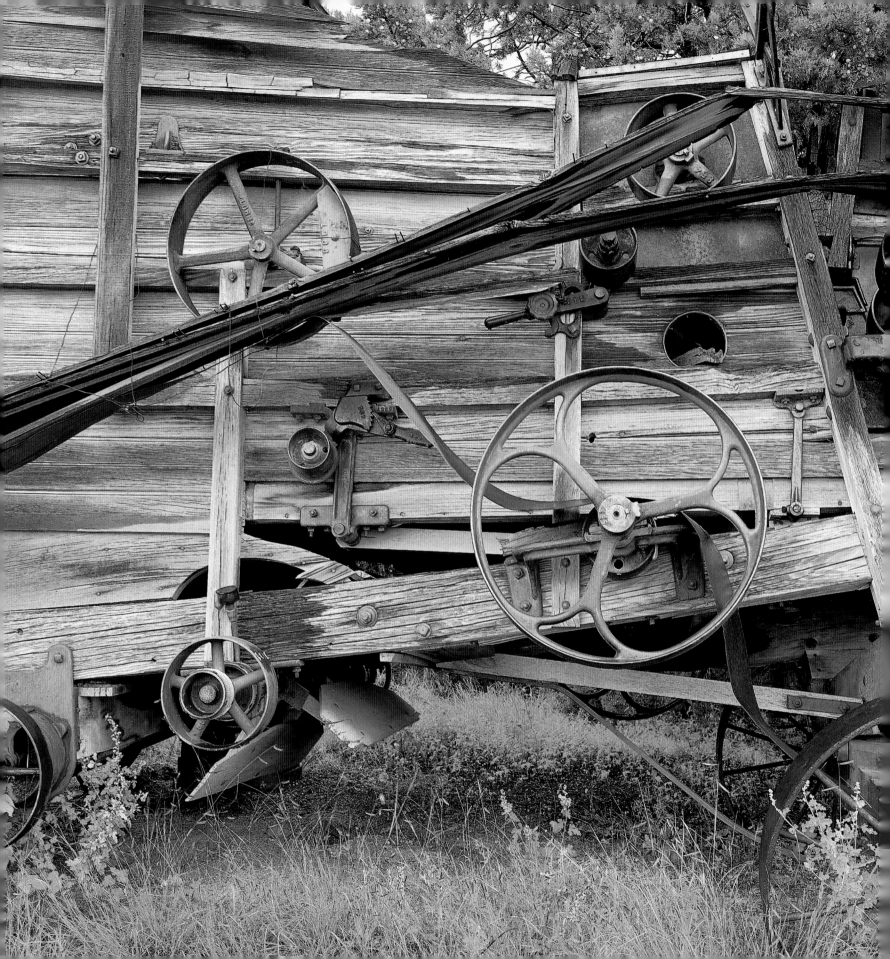

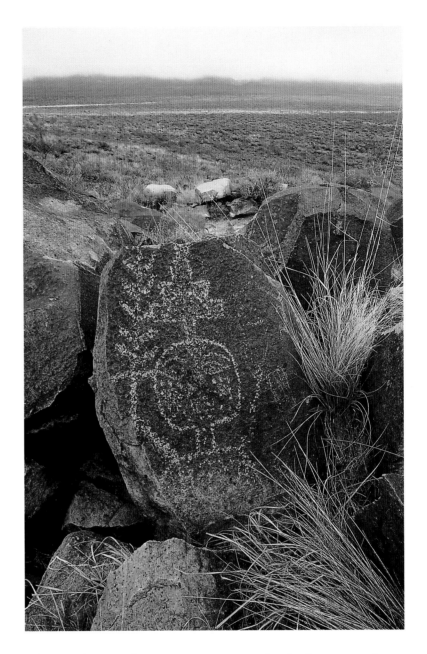

The rocks at Three Rivers Petroglyph Site reveal thousands of carvings. Unlike pictographs, which are painted, petroglyphs are actually carved or chipped into the rock.

An antique threshing display shows visitors the farming tools of the past at Pinos Altos, half ghost town and half artists' community near Silver City.

In 1875, prospectors struck gold-bearing quartz in New Mexico's southwest corner. Some towns produced millions of dollars worth of gold and silver before they were abandoned in the early 20th century.

OPPOSITE—
Aguirre Springs National Recreation Area offers visitors a close-up look at desert plants and animals, including the giant Our Lord's Candle yucca. The yucca is one of New Mexico's state symbols.

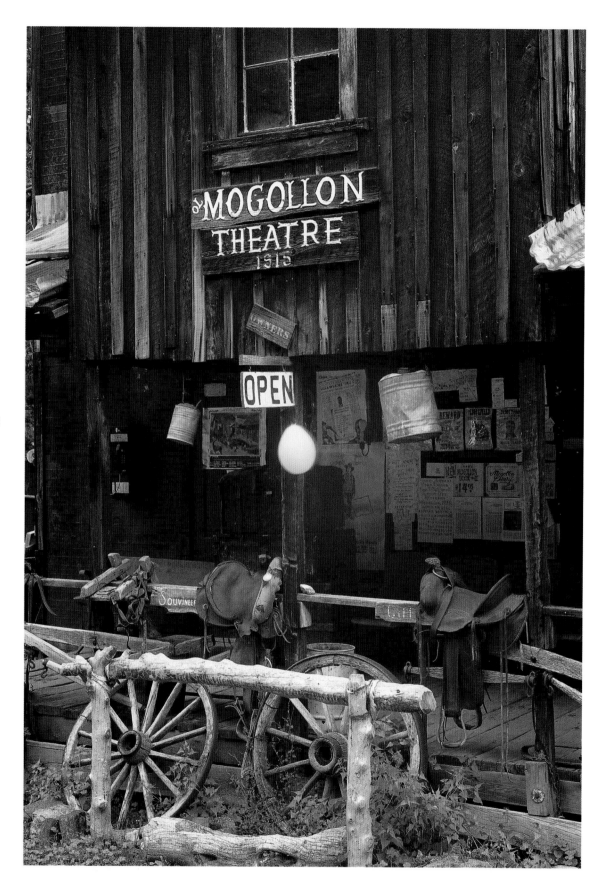

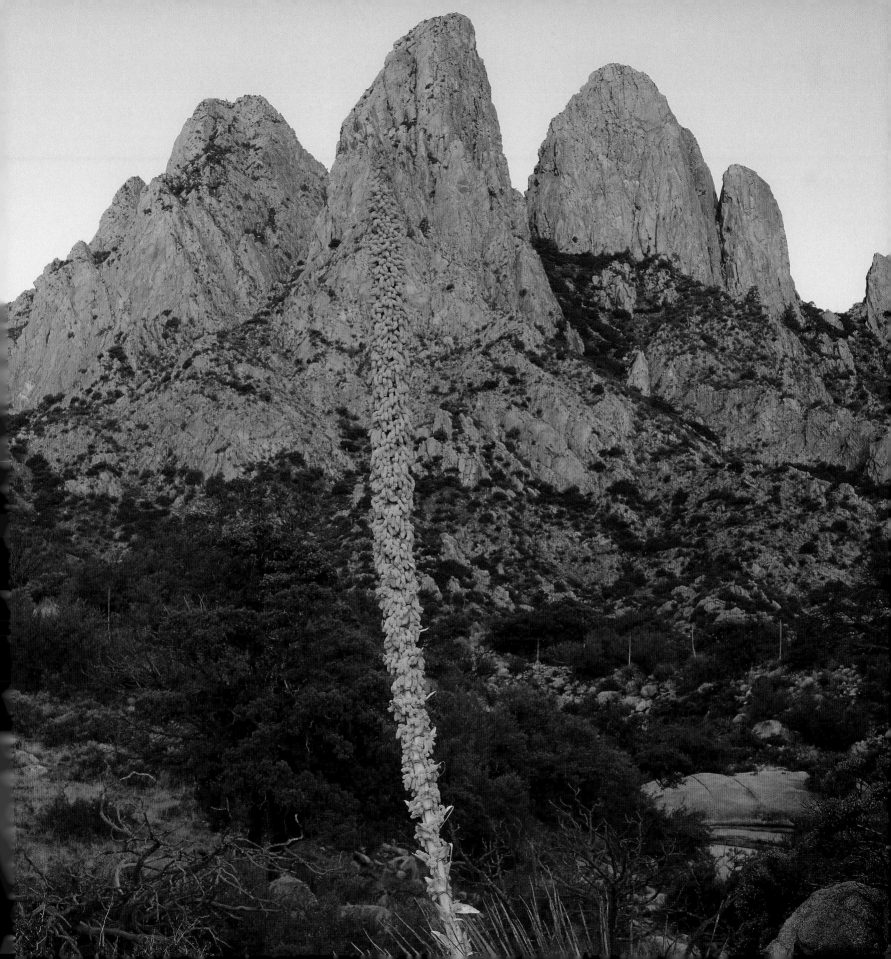

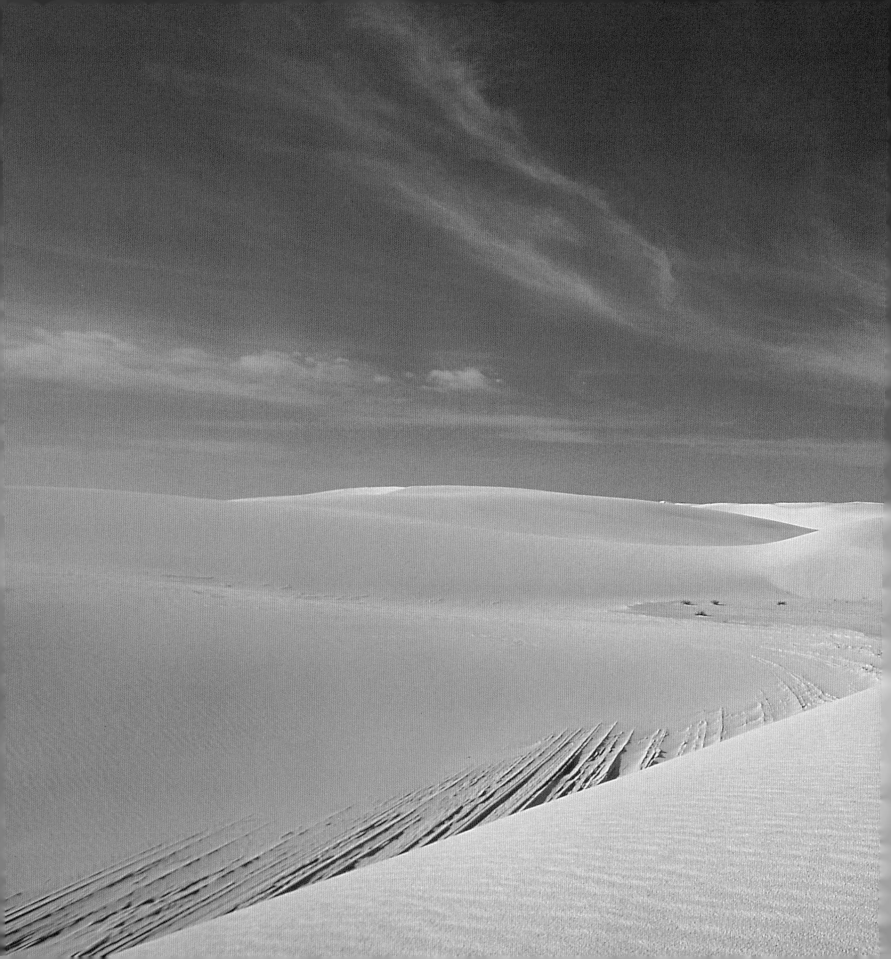

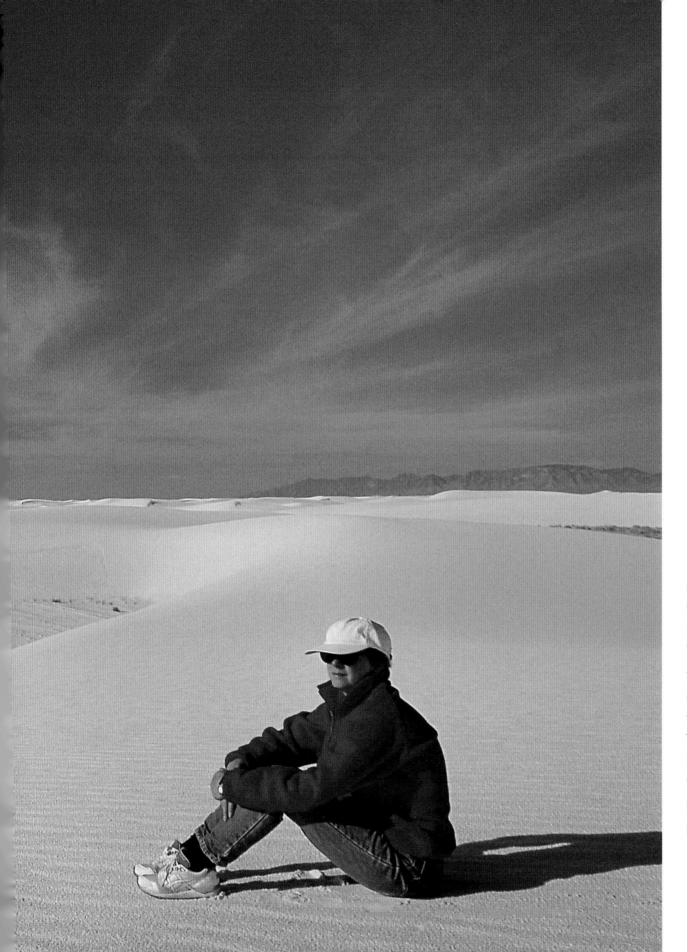

Constantly ground, moved, and sifted by the wind, the world's largest deposit of white gypsum sands creates an other-worldly landscape at White Sands National Monument. The gypsum was deposited here by an ancient sea.

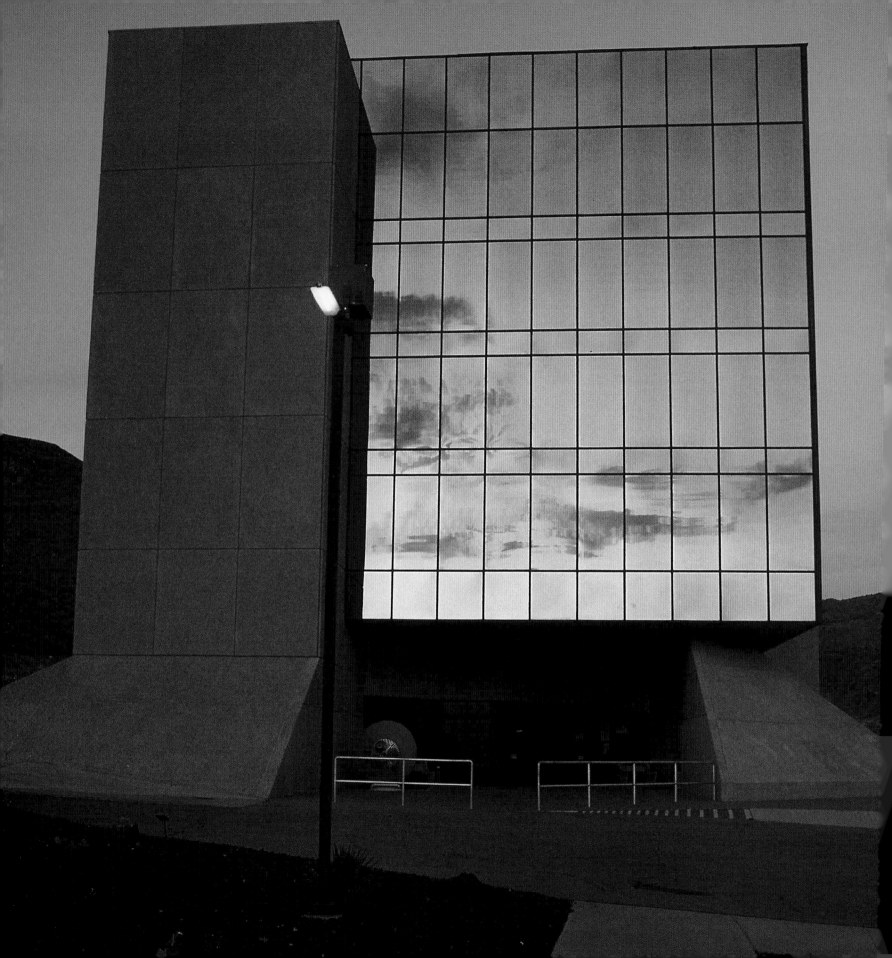

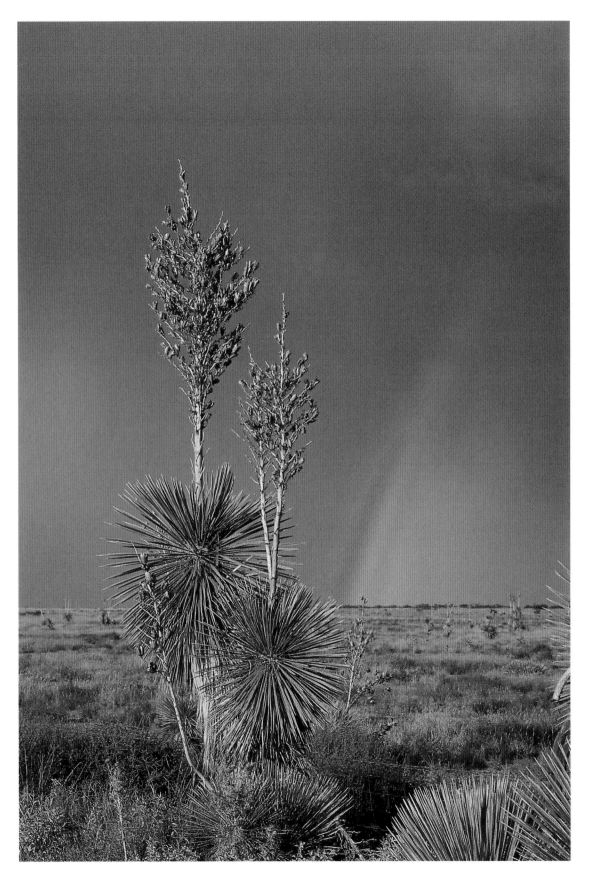

The yucca actually belongs to the lily family. Blooming every spring, yucca flowers attract birds, bats, and several varieties of specialized yucca moths, which pollinate the plants.

OPPOSITE—
At the International Space Hall of Fame in Alamogordo, sightseers can examine artifacts from numerous international missions, including life-support systems, space suits, satellites, and more. The cubic design of the museum won a New Mexico Arts Commission Award for architecture.

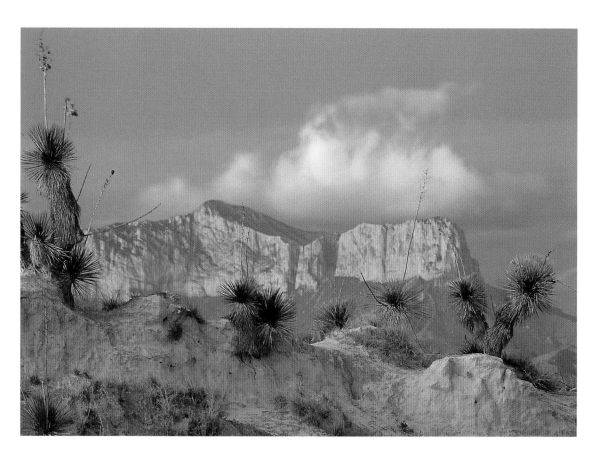

Most people imagine deserts and dry hills such as these when they think of New Mexico, but about 40 percent of the state is forested.

An elevator has replaced the wooden buckets that once lowered visitors into Carlsbad Caverns, an enormous cave network that was once part of a prehistoric reef. The caverns were declared a national park in 1930.

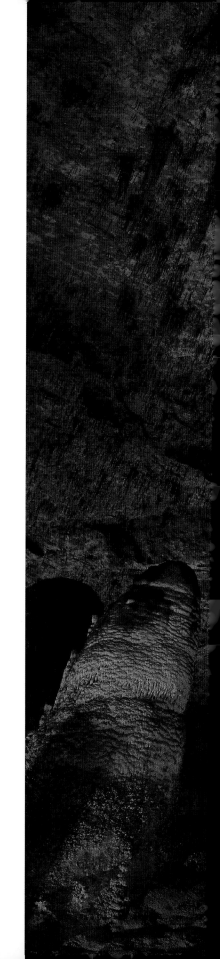

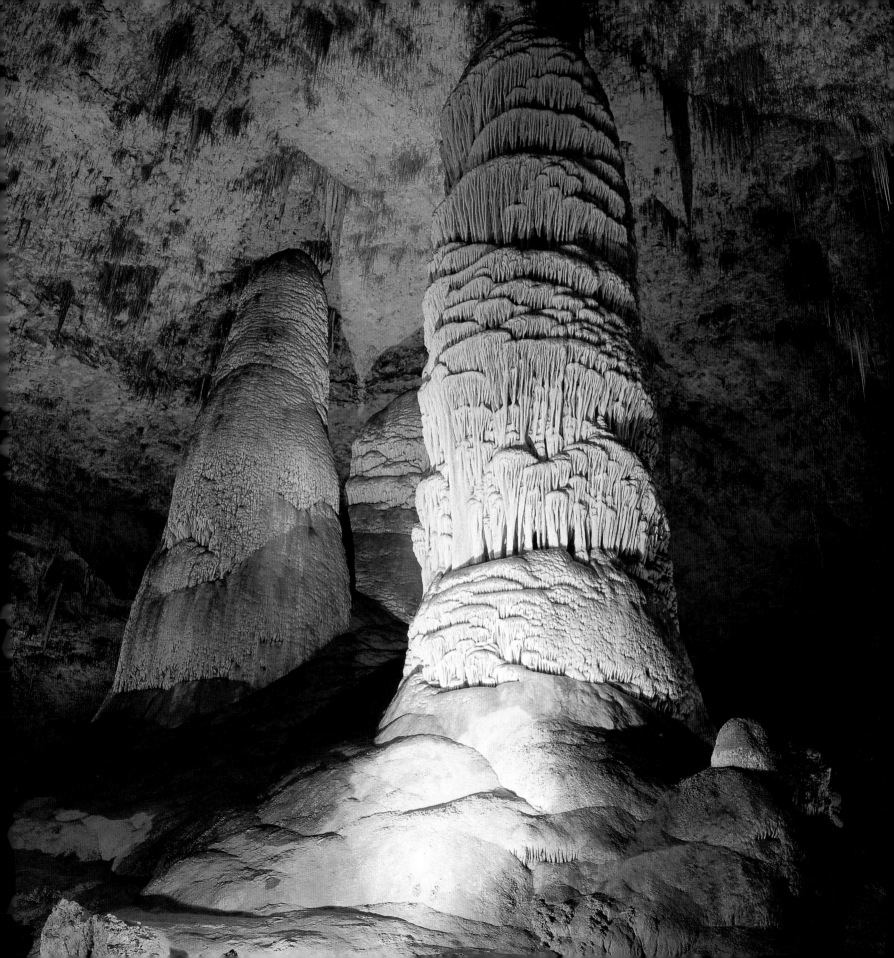

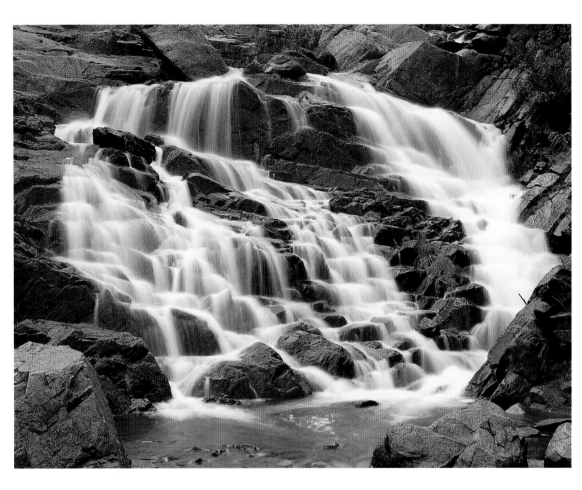

A waterfall cascades over the edge of Bear Canyon in Lincoln National Forest.

Travelers pass Chimney Rock as they hike through Carson National Forest on the Continental Divide Trail. This six-month trek runs from the Rocky Mountains of Canada south to Mexico.

Photo Credits

Ron Watts/First Light 1, 3, 20–21, 23

Tom Till 6–7, 10–11, 13, 16–17, 18, 24–25, 28–29, 30, 31, 33,
34, 43, 46, 47, 68–69, 78, 79, 80–81, 84, 86, 87, 93, 94, 95

George H. H. Huey/First Light 8

David L. Brown/First Light 9, 67, 71, 75

Rudi Holnsteiner 12, 22, 53, 55, 58–59

Tim Fitzharris 14, 39, 44–45, 48–49, 92

Brian Parker/First Light 15, 32, 64, 70

Wendy McEahern 19, 38, 40–41, 50, 51, 52, 54, 65

Pat Morrow/First Light 26

Ron Watts 27, 35, 88–89

Alan Sirulnikoff/First Light 36–37, 60, 74

John Cancalosi/First Light 42, 90

Jürgen Vogt 56–57, 61, 62–63, 91

Alan Sirulnikoff 66

Craig Aurness/First Light 72–73

Jeff Foott/First Light 76–77, 82–83, 85